LIVERPOOL'S MILITARY HERITAGE

Ken Pye FRSA

AMBERLEY

First published 2018

Amberley Publishing
The Hill, Stroud
Gloucestershire, GL5 4EP

www.amberley-books.com

Copyright © Ken Pye FRSA, 2018

Logo source material courtesy of Gerry van Tonder

The right of Ken Pye FRSA to be identified as the
Author of this work has been asserted in accordance
with the Copyrights, Designs and Patents Act 1988.

ISBN 978 1 4456 8862 6 (print)
ISBN 978 1 4456 8863 3 (ebook)

British Library Cataloguing in Publication Data.
A catalogue record for this book is available from the
British Library.

Origination by Amberley Publishing.
Printed in Great Britain.

Contents

Introduction

When one thinks of Liverpool today one thinks immediately of the River Mersey and its docks and warehouses. One also thinks of The Beatles and the rock and pop 'Merseybeat' era of the 1960s.

One might also recall an era of strikes, economic collapse, and of social unrest that, in the late 1970s and early 1980s, led to the Toxteth riots. At the time these were the most violent civil disturbances ever on the British mainland since the English Civil War of the seventeenth century.

Fortunately, however, to think of Liverpool today is to recognise a metropolis that is a European Capital of Culture and a UNESCO World Heritage Port and City. It now sits as the hub of an exciting and vibrant conurbation and has fully reclaimed its global status as a World-Class City.

However, what few people would consider when thinking of Liverpool is of a place originally founded solely for war – but such is indeed the case.

Ancient 'Leverpul' was once nothing more than a tiny fishing hamlet nestling on the shore of a large, tidal inlet off an obscure north-western river, named the 'Mer-sea'. This 'Pool' was also fed from the east by a wide creek, rising in the hills overlooking the river.

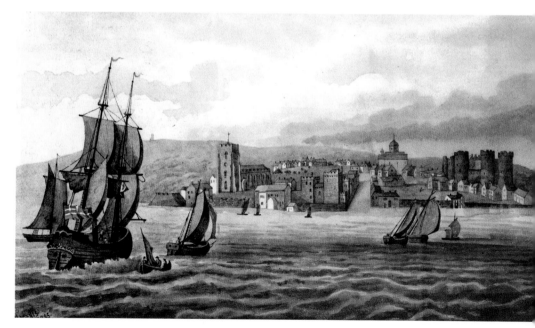

The Liverpool waterfront in the sixteenth century. (Courtesy of Discover Liverpool Library)

The little community was so insignificant that William the Conqueror (*c.* 1028–87) did not even list it in his Domesday Book of 1086. This was the Norman invader's great ledger of all he had claimed ownership of since his victory and conquest of England at the Battle of Hastings in 1066.

Yet, only 140 years later, this small collection of fishermen's cottages and an ancient chapel would be transformed into a base for a belligerent king's army and navy, and a starting place of military conquest. Indeed, had it not been for war, the community that would grow into the great city of Liverpool might simply have faded away into oblivion.

But this was not to be, and Liverpool became a vital centre of global maritime trade and commerce, essential to the British economy. For 250 years it was also the 'Second City of the British Empire' after London. During its history Liverpool has also been a heavily

A page from William the Conqueror's great Domesday Book. (Courtesy of Discover Liverpool Library)

fortified military base. Not only would foreign military and naval campaigns be launched from here, but it would also have to defend itself, many times, and repel would-be invaders. In fact, in the millennia before its founding, the ancient Celtic inhabitants of the area had fought for survival against ancient Roman and Viking enemies.

In the centuries after the Norman Conquest, Liverpudlians and their neighbours played a significant role in national and international military and naval conflicts and, in the greatest war of all, actually saved Britain from defeat.

This book is about Liverpool's military heritage, which is principally a story of soldiering and some, but not a great deal, of naval warfare. Any role played by the airforce, though important, has only really been significant in the Second World War, so this does not actually constitute 'heritage'. Consequently, I have not written about the role of the RAF or the USAF in Liverpool's history, as these are covered in some of my other publications and are not really material to this narrative. However, what I have included tells the story of how we became, remained, and will – if only to a limited extent – continue to be a military city, albeit in a unique way.

Liverpool has never been a Royal Naval port like Plymouth, Chatham, or London; nor an air force town like Brize Norton, Coningsby, or Northolt; neither has it ever been an army garrison town, like Colchester, Aldershot, or Salisbury. Even so, throughout its history, the city's military role has undoubtedly been essential and, in some cases, pivotal. This means that the military heritage of Liverpool and its people is very real, significant, and worthy of celebration and honour.

Ken Pye FRSA
Liverpool

1. The Invaders of Liverpool and their Legacy

Even before the founding of Liverpool, in the early thirteenth century, both sides of the Mersey had been occupied by the earliest peoples. In the Neolithic or New Stone Age period, which began around 9,500 BC, boat people fished in the Mersey around what would become Rock Ferry, Woodside, Birkenhead, and Wallasey, and in and around what would eventually become known as the Pool of Liverpool. They navigated the coastal waters in primitive, hollowed-out logs and, later, in coracles.

Evidence of one of the earliest known inland human settlements in Britain has been found at Irby on Wirral. Arrowheads and flint tools excavated here, and around the Liverpool area too, date back to the Mesolithic period, or Middle Stone Age – around 7,000 BC.

By the time of the Iron Age, which lasted from around 450 BC up to the first, unsuccessful, Roman invasion of Britain, in 55 BC, by Julius Caesar (100 BC–44 BC), local Celtic people had developed sophisticated, social and community structures and hierarchies. They also created complex theologies and forms of worship to explain the great mysteries of their existence and environment.

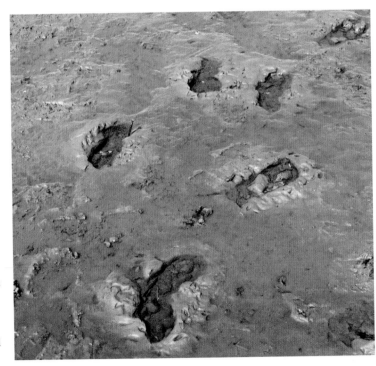

Prehistoric footprints found at Formby to the north of Liverpool. (Courtesy of Discover Liverpool Library)

General Julius Caesar had first attacked Britain at the Kent coast, with ninety-eight ships carrying two legions each of 20,000 men. The response from the native Britons was severe and brutal, and he was soon repelled. But this was only a temporary reprieve because Caesar's next attack was the following year. This time he was better prepared. He now attacked Britain with 800 ships, this time carrying 50,000 soldiers and 2,000 cavalry. He conquered the south-eastern Celtic tribes, but left again three months later with his entire army.

The Romans did not come back again until AD 43, but this time they were under the command of Emperor Claudius (10 BC–54 AD). He was absolutely determined to completely subjugate the country and its wild, warrior, Celtic inhabitants, no matter what this cost in time or men. And it took decades because the tribespeople put up a ferocious defence. In fact, it was not until around AD 70–79 that he got to the north-west of England, hacking, slashing, spearing, mutilating, impaling, and beheading every step of the way. He left the heads of defeated tribal chieftains stuck on pikes as a warning to others.

In the first century AD, as well as making their way north overland, the Romans landed their galleys at various places on the Lancashire coast and used these as incursion points. They established a large, inland military stronghold at Bremetennacum – now modern Ribchester – between Blackburn and Preston. From this fortified outpost they regularly marched to and from their larger and more strategically located settlement at Deva, which is now modern Chester.

En route, they passed through what would become the suburban, riverside, Liverpool districts of Garston, Woolton, and Speke. Indeed, in the mid-nineteenth century, during road excavations in Garston, the remains of a Roman pavement were discovered as well as some coins. Roman coins have also been found in other suburban locations such as Toxteth, West Derby, Wavertree, and Tarbock.

The Iron Age Britons fiercely defended their homes, communities, and lands, especially in what were to become Liverpool and Merseyside. There is some evidence of this at the summit of the 250-foot-high Camp Hill, which is close to Woolton Village at the southern

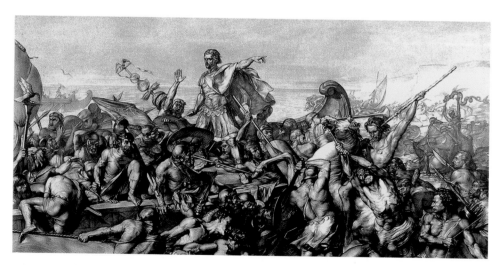

Julius Caesar invades Britain in 55 BC.

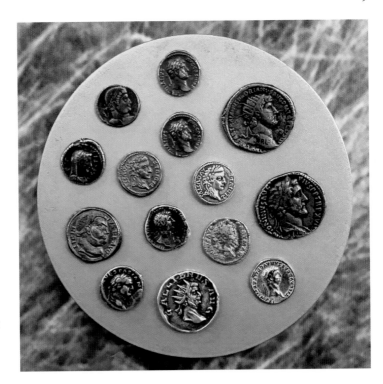

Roman coins found at Liverpool. (Courtesy of Discover Liverpool Library)

end of the modern city. In 1948, during the demolition of some buildings at the top of the hill, remnants of an ancient, fortified, Iron Age encampment were found. This discovery proved what local people had believed for centuries: that the ancient Britons had constructed a defensive outpost here to protect their surrounding farms and fields. This also explained why, for generations, the hill had been known as 'Camp Hill'.

Before the Romans first came to Britain, perhaps from as early as 150 BC, this hill had been the home of the local tribespeople, the Brigantes. This confederation of largely independent communities controlled the largest section of what would become northern England, as well as a significant part of the north Midlands. Their Camp Hill fortification was around 80 yards in diameter, with ramparts between 10 feet and 15 feet high, and was probably encircled by defensive, sharpened wooden stakes.

From the top of Camp Hill, even today, the views are spectacular of the surrounding lands, of the River Mersey, the Wirral Peninsular, and of the far mountains of North Wales, so this was an ideal location for the competitive local Celts. They would have challenged other nearby tribes for power and territory from here, and defended themselves against the Romans when they came.

These aggressors also probably marched past Camp Hill on their way from Bremetennacum to Deva. The Brigantean hill fort would have been a prime target for the Romans, and it is also probable that they mounted at least one attack against its primitive defenders. It is believed that Gnaeus Julius Agricola (AD 40–93), was Governor of Britain from AD 78 to 84. He led major attacks against the Brigantes, although it took many years to finally subdue them.

Camp Hill at Woolton, as it appears today. This was once the tribal home of an ancient Brigantean community. (Courtesy of Discover Liverpool Library)

If it is the case that their troops did mount an assault on the hill fort then they would have been very heavily armed and armoured. Their forces would have advanced against their enemies in ordered ranks, carrying their shields to protect their neighbours. Their short broadswords would have been drawn ready for close-quarter slaughter.

However, Roman records from the time describe their fear of the 'barbarian Britons', which is hardly surprising. They reported that their Celtic enemies mostly fought entirely naked, with their bodies painted with blue woad extracted from plants. The Brigantean warriors often also wore their long hair, moustaches, beards and body hair caked with lime paste and twisted into long, bright-white spikes.

It is easy to visualise the Roman soldiers in their smart uniforms and burnished armour, their weapons at the ready, lined up at the base of the hill in serried and orderly ranks. One can also imagine the daunting spectacle of hundreds of powerful, enraged, hairy, spikey, totally naked blue men (and sometimes the women and older children as well) gathered at the top of Camp Hill.

Also heavily armed, with fearsome, long, slender slashing swords and vicious spears, the Celts would have charged down the hill screaming defiantly and proudly brandishing every weapon they had, especially their less-metallic ones! Throwing themselves against the enemy in furious abandon the terrifying effect that these rampant tribespeople had on their enemies can only be imagined!

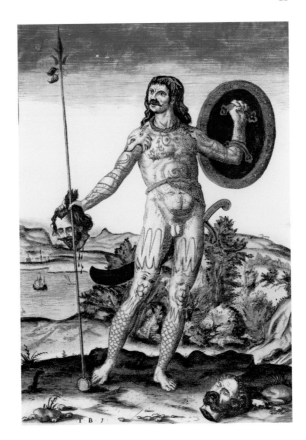

Brigantean warrior with his body decorated with woad. (Courtesy of Discover Liverpool Library)

Perhaps the fact that no evidence has yet been discovered that the Romans ever occupied the summit of Camp Hill shows that they never came there at all. Or perhaps the dreadful sight of such a flapping, flailing, marauding mob of nude early Liverpudlians was sufficient deterrent to frighten off the advancing Italians!

But the Romans were not the only ruthless invaders that the early people of Liverpool had to do battle with, far from it. In AD 410, the Emperor Honorious (AD 384–423) withdrew all Romans from Britain, telling the country that we now had to fend for ourselves. The Dark Ages had begun.

In AD 731, Bede (AD 672–735), an Anglo-Saxon monk in the monastery of Jarrow in Northumberland, wrote *The Ecclesiastical History of the English People.* In this work he tells that from AD 449 other warlike peoples from Europe set their sights on the land across the Channel. During the sixth and seventh centuries, peoples known as Angles, Saxons, and Jutes invaded Britain. They came, respectively, from eastern Schleswig-Holstein, northern Germany, and the Jutland peninsula of present-day Denmark. These warring tribes battled their way across Britain to arrive in the territories that would eventually become Liverpool and Merseyside.

Like their predecessors, as they made their way across the country they initially fought brutally with the local Celtic inhabitants. However, and also like the Romans, they too ultimately married into the indigenous people and then settled down and farmed

the land. This all added to the cultural mix that evolved into Anglo-Saxon Britain. Yet again, though, the relative peace of primitive Liverpool and Merseyside did not last for long. This was because from the eighth century onwards a race of new, sea-born aggressors began to invade our shores, this time from Scandinavia.

Arriving here in fleets of 'longships', driven by sails, oars, and a bloodthirsty determination to conquer, these warriors wrote the next chapter in Britain's bloody history, especially in north-west England and the ancient territories that were to become Merseyside.

Known to history as the Vikings, they were strong, proud, and relentless. With as many as 100 men in each vessel they sailed across the icy and treacherous North Sea. Seated on benches on open decks, they were completely exposed to the elements; these raiders were fearsome indeed. Their wooden warships could be up to 40 yards long and were steered by a single oar at the rear. Travelling at up to 10 or 11 knots these were powerful vessels. Their prows and sterns were surmounted by awesome carved figureheads in the form of great dragons and monsters. These were designed to strike terror in their enemies as they approached the land.

Known also as Norsemen, they came from Sweden, Denmark, and Norway, and struck with terrible violence. Then they rapidly moved on before any local defensive force could muster. Raids by single longships were frequent, but fleets of up to 100 ships could mount a single attack. As the Vikings became more familiar with our geography and bolder as a result, fleets of up to 200 ships would be sighted approaching the land. Horrified observers might run to warn people to escape, but often to no avail.

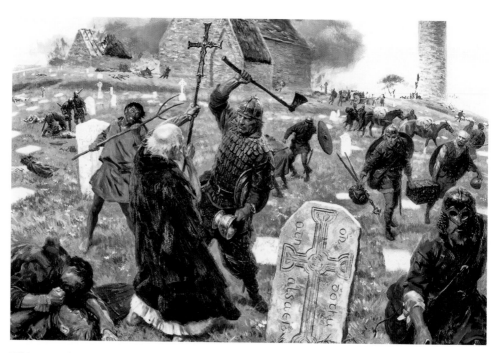

Viking attack on an English monastery.

The first Viking attack on Britain came in the year AD 793, when they sacked the Northumbrian island monastery at Lindisfarne, sending a wave of shock, outrage, and fear across Western Europe. These determined people now regarded the rest of Britain as a legitimate target for looting and despoiling. Their first raid by the Vikings on mainland England was recorded in Wessex, in AD 855, but then they also targeted Ireland, Scotland, Wales, and Cornwall.

However, the Danes specifically set their sights on north-east and north-western England, and they were the race who exploited and subjugated the Liverpool and Merseyside areas of that time. Their first landing points in our scattered, rural villages were at what are now Crosby, just north of modern Liverpool, and at Meols, on the north Wirral peninsular. A wide variety of Norse artefacts continue to be discovered at both of these coastal locations.

The Vikings voyaged far from their cold and often hostile lands and, like other invaders before them, were really only looking for new places in which to set up home. The Norsemen sailed their longboats up the River Mersey, the Alt and the Dee, and they settled in south Lancashire and north Cheshire areas in significant numbers.

Eventually, treaties were agreed and hostilities ended, as the Norse invaders eventually settled and married into the local Anglo-Saxon communities. Just like the Romans, Angles, Saxons, and Jutes before them, the Vikings too married local women, settled down and became merchants, fishermen and farmers on England's green and pleasant land.

Vikings now helped to establish new communities whilst strengthening and developing older ones. We see this legacy all around us on modern Merseyside, in the names of our suburbs, villages, and towns, such as Ormskirk, Kirkby, Fazakerley, Garston, Toxteth, Hale, and Knowsley. But once again the 'jewel set in a silver sea' drew the attention of yet another invading force.

This time it was the Normans, under the command of William the Conqueror (c. 1028–87), who crossed the Channel in force to attack England. However, the violence of their assault and subjugation of the country and its people was arguably greater than that of any previous invading army.

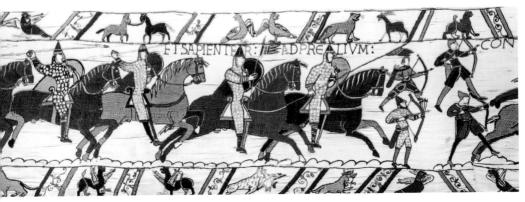

The Battle of Hastings as depicted in the Bayeux Tapestry. (Courtesy of Discover Liverpool Library)

The Norman victory was total, and they brought with them a long-established and rigidly structured administration. Known as the 'feudal system', this method of ruling the country kept everyone – from peasant to aristocrat – in their place in a strict and immovable social and political hierarchy. This established the class system in Britain that, in many ways, survives today.

The Normans were also determined to obliterate every vestige of the indigenous culture, and in this they succeeded completely. In effect they made Britain a Norman colony and almost every example of Anglo-Saxon society and heritage was wiped out.

The feudal system sank deep roots into the fabric of English society and nowhere more so than in the communities on the shores of the Mersey. This included the small fishing hamlet of Leverpul, quietly going about its simple life, on the edge of its very broad, deep Pool. It was this body of water that would now forever redirect the fortunes of the district and its people.

These changes were brought about because of the warmongering political ambitions and belligerent personality of John Plantagenet (1166–1216), King of England, son of Henry II (1133–89), and descendant of William the Conqueror.

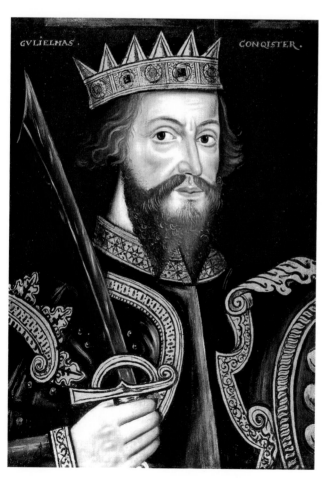

William of Normandy – The Conqueror. (Courtesy of Discover Liverpool Library)

2. Ireland, the King, and 'Leverpul'

The life and history of Liverpool following the Norman Conquest of 1066 really begins back when English kings first claimed the rule of previously independent Ireland. This country had been ruled by its own kings until, in 1154, Pope Adrian IV (1100–59) granted significant areas of Irish territory to King Henry II of England. This was because Adrian wanted the English to bring the Irish Church under the control of the Roman Church. Henry was only too willing to oblige, because this meant more territory, wealth, and power for him.

Even so, the king did not actually take control of his new Irish lands until 1175, with the signing of the Treaty of Windsor. This gave him title to areas including Meath, Leinster, and parts around Dublin, Wexford, and Waterford. The remainder of the country was, ostensibly, to remain under Irish rule.

By 1177, though, Henry II had extended his territory by simply taking land from Irish kings. In this same year the king made his youngest son, Prince John, Lord of Ireland. This action showed the Irish that the English were determined to maintain their rule over parts of their country, and they believed that Henry's ambitions would not stop there.

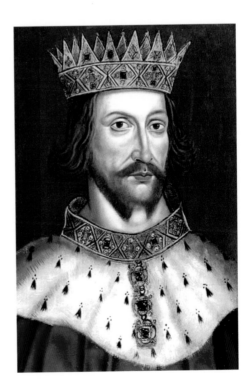

Henry II, the first English monarch to claim rule over Ireland. (Courtesy of Discover Liverpool Library)

Over time, to forestall more land seizures, and because Henry was imposing the hated feudal system in his new territories, the Irish lords began to rebel. They became a continual thorn in the side of the aging monarch.

So, in April 1185, at the urging of his father and at the age of eighteen, Prince John went to Ireland to assume his Lordship of Ireland in person. He landed at Waterford with around 300 knights and numerous foot soldiers and archers, but he was soundly defeated by the Irish, losing almost his entire army and some of his most senior knights. To his great embarrassment, John was forced to retreat to England after only nine months.

In 1199, and having outlived his father and three older brothers, John became King of England. He had succeeded his brother, King Richard (1157–99), known as 'Lionheart'. Richard had been popular among the English people, even though he had spent most of his reign in the Holy Land fighting the Crusades. John could not hope to match the affection his brother had won. He was generally hated by his subjects and rejected by his aristocratic peers.

John desperately needed a military victory to try to win the respect of his countrymen and he felt that Ireland could provide this. He reasoned that a successful assault on the exploited country across the Irish Sea might achieve his political ambitions. It might also settle the continuing rebellion by certain Irish kings, as well as most of the Anglo-Norman settlers in Ireland, who hated John just as much as its own people did.

In 1207, John planned to send his new campaign of conquest against the land across the Irish Sea. However, to do so he needed a deepwater west coast port from which to launch his invasion fleets. Milford Haven in Wales was an obvious choice, but the local tribes were too hostile. The second option, Chester, was too strictly controlled by the

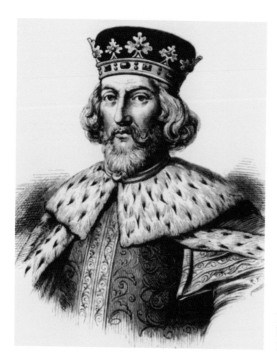

King John, the founder of 'Leverpul', which became Liverpool. (Courtesy of Discover Liverpool Library)

dominant local landowner, Ranulf de Gernon (1172–1232), 4th Earl of Chester. He was a petty monarch in his own right and certainly no friend to John – not that the petulant king had many friends anyway.

In the year 1206, John had visited the north of England. Records show that on 26th February he stayed at Lancaster and on 28th February he was at Chester. While there is no evidence that he passed through the fishing hamlet of Leverpul, in the light of his subsequent actions it seems very likely that he did so. It is certain that he knew of the place and of its large, sheltered tidal 'Pool'.

He was obviously already aware that this natural harbour was broad, deep, and big enough to anchor a full fleet of ships. Also, as this was far enough away from the influence of Ranulf, Leverpul seemed ideal for his military purposes: not only could he invade Ireland from this new base, but also Scotland, Wales, and the Isle of Man. However, to do so he needed people to build his fleet, to provision his army and sailors, and an economy to sustain all of this.

On 23rd August 1207, the king claimed control of the entire 'Leverpul' area for the Crown, from the local lord of the manor, Henry Fitzwarine (dates unknown). Five days later he awarded the previously obscure community his letters patent, or charter, thus creating a new town and borough that was to steadily evolve into modern Liverpool.

The great forest of Stochestede (Toxteth), just to the south of the Pool, was another attraction for the king. Its vast numbers of ancient, sturdy oak trees would provide all the timber necessary to construct his invasion fleets, as well as the homes and buildings of the new town. The forest stretched southward from what is now Parliament Street to Aigburth and Otterspool, and eastward from the banks of the Mersey to the manor of Esmedune (Smithdown) on the edges of Wavertree.

King John on a hunting expedition. (Courtesy of Discover Liverpool Library)

Also, the forest was home to a variety of game, including boar, deer, rabbits, and game birds. John now claimed this as his own private royal hunting forest, and he surrounded it with a high wall, built lodges to guard its entrances, and installed gamekeepers, wardens, huntsmen, stables, and hounds. The fact that he went to such lengths to secure and develop the area, and spent such time, money, and resources on his forest, makes it almost certain that the king did indeed come to Liverpool, and probably on more than one occasion.

John also granted authority for his town to hold annual markets, so establishing it as a significant centre of trade and enterprise. Little did the king know that this would begin Liverpool's development into a centre of global commerce. Also, the small port on the Mersey was destined to eventually connect directly across the 'Seven Seas', with the ports, cities, and nations of the entire world.

Three years after he had founded Liverpool John was now ready to make his second trip to Ireland. On 20 June 1210, he landed at Crook near Waterford, by which time his expertise as a military commander had improved significantly. He arrived with over 7,000 knights, archers, and infantry, carried in 700 vessels. This attack was a complete success and he was able to subjugate the rebel forces. He also rebuilt many Irish castles damaged in the rebellion and constructed a number of new ones.

John held negotiations with the Irish kings in the summer of 1210, which ended in his favour and he seemingly left Ireland on good terms with them. However, the victorious king then decreed that English common law was to be the only law in Ireland and, from that same year, the whole of the country was now effectively directly governed from Westminster and London. The following year a chronicler wrote, 'At this time there was

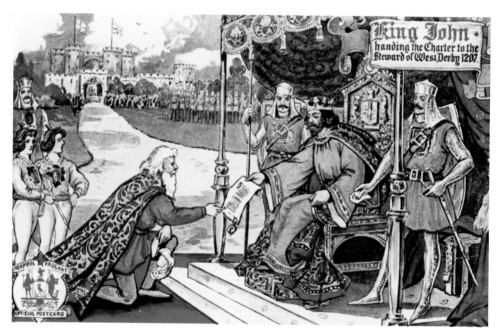

Edwardian postcard showing King John presenting his charter founding the town, port, and borough of 'Leverpul'. (Courtesy of Discover Liverpool Library)

The royal crest for the Lordship of Ireland. (Courtesy of Discover Liverpool Library)

no longer any rival in power to the King of England in Ireland, Scotland or Wales; which was not something one could have said about any of his ancestors.'

While John remained Lord of Ireland throughout his reign, all was far from well at home in England. Life under successive Plantagenet monarchs had been harsh and brutal, but under John it was particularly bad – for both the peasantry and the aristocracy. Said to have been a selfish, spoilt, sullen, and vindictive man who was given to childish tantrums, the king has passed into popular history as 'Bad King John'.

Apart from his victory in Ireland John was seldom successful in battle, earning himself the nickname of Softsword, which did not only belittle his prowess on the battlefield! When he had come to the throne he had inherited a vast empire in France, but by the time of his death he had lost most of this, earning himself another nickname, as John Lackland.

In 1215, the barons of England had had enough of John's effective dismissal of their authority and privileges, and were tired of his determination to have sole authority in his kingdoms and over them. They rebelled and forced John to sign the document that became the foundation of English civil rights: the Magna Carta.

John died from dysentery in 1216, with very little mourning. But, at least, he had done one remarkable thing in founding Liverpool. In the years immediately after the king's death the town and its harbour pool took on a new strategic significance. The population increased significantly, and maritime trade with Ireland, Scotland, Wales, the Isle of Man, and around the coast of Britain, became the foundation and heart of Liverpool's burgeoning economy. Because of John's invasion plans the town soon had many soldiers and sailors billeted there and so, by default, it had developed into a military town.

Such martial importance and financial significance required appropriate defences. These would begin with the building of the great Liverpool Castle, followed by the creation of the grisly, and equally imposing, Tower of Liverpool.

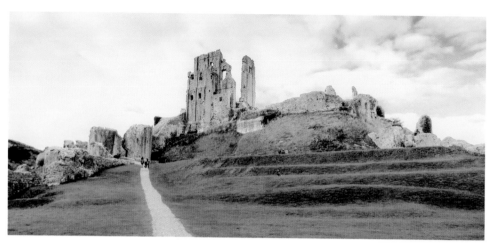

The ruins of Corfe Castle, where King John had Maud de Braose and her son walled up alive to starve to death. (Courtesy of Tallguyuk under Creative Commons 3.0)

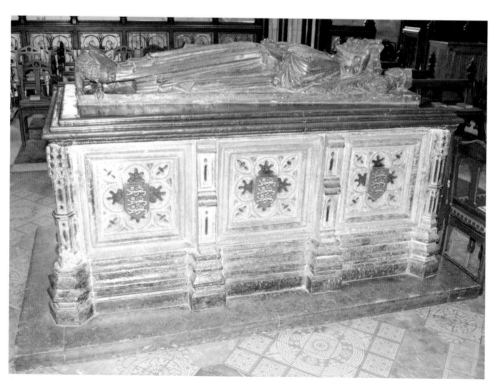

Tomb of King John in Worcester Cathedral.

3. The Military Bastions of Liverpool

With the founding of Liverpool in 1207, King John ordered that seven streets be laid out at the heart of his new town. These survive today in their original positions and as main thoroughfares in the modern city. They run in a 'H' pattern with an extended central bar, and many still have their original names.

One of these, Castle Street, leads from Liverpool Town Hall, as its name suggests, to where Liverpool Castle once stood on what is now named Derby Square.

In all probability this was built on the orders of the king and on the site of an earlier manor house. The work was completed sometime between 1232 and 1237, after John's death in 1216. Construction was overseen by the then Lord of the Manor of Leverpul and Sheriff of Lancaster, William de Ferrers (1193–54); the great bastion would stand for around 500 years.

This was an impressive stone structure, which dominated a ridge that was the highest point in the tiny town. It was in a particularly strategic position as it afforded excellent views, not only of the Pool and its creek, the river, its estuary, and across to the Wirral Peninsula, but also of all the land for miles around. It was built out of massive blocks

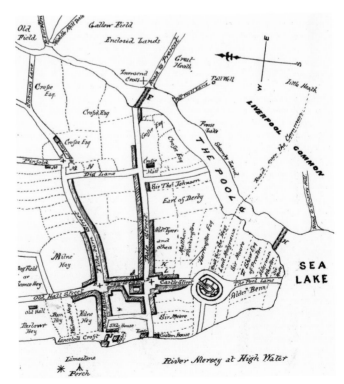

Map showing the layout of the original seven streets of Liverpool. (Courtesy of Discover Liverpool Library)

of sandstone that had been hewn out of the bedrock to leave a great moat. Excavations carried out on the site in 1927 showed that this completely encircled the huge fortress and was around 15 to 16 yards wide and 7 yards deep, with very steep sides.

The castle was rectangular in design, with tall, broad, circular towers at three of its corners. It had a large gatehouse, barbican, and portcullis at its fourth, which guarded the entrance. This was accessed over a drawbridge on a causeway across the moat. The castle towers and barbican were connected by high curtain walls topped by battlements, and these strong defences enclosed a broad courtyard. Another tower was added in 1441. The building also had deep cellars and dark, damp dungeons.

Within its walls were barracks for troops, stores of armaments and weaponry, a forge, warehouses, and corrals for livestock and horses. The castle was designed to be self-sufficient in times of siege and so it had its own bakehouse, brewhouse, and well. Just beyond the walls was an apple orchard on the west side, overlooking the river, and a stone-built dovecot to the south.

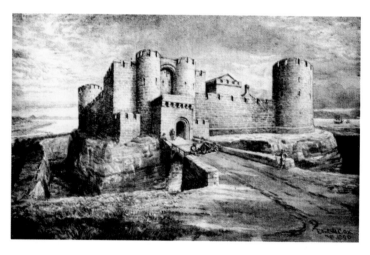

Liverpool Castle, showing its wide, deep moat, and with the 'Pool' of Liverpool behind, as a large inlet of the Mersey. (Courtesy of Discover Liverpool Library)

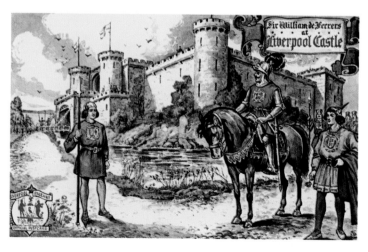

Edwardian postcard depicting William de Ferrers and Liverpool Castle. (Courtesy of Discover Liverpool Library)

The De Ferrers family, their servants, and their soldiers, occupied the castle until 1266, when it was taken over by other nobles. By 1347, the castle's facilities had developed and there were now a large hall and a chapel in the main courtyard. The hall was big enough to be a dining space for all the occupants, which also provided indoor stabling for the horses and other animals.

By the early fifteenth century the castle was permanently garrisoned with troops from the private army of one of Liverpool's two great aristocratic families, the Molyneuxs. They were descended from a Norman mercenary by the name of Guillaume De Molines (c. 1030–c. 1070–85), which translates as William the Miller. He had taken advantage of the opportunity to come to Britain with William the Conqueror in 1066 and had won vast estates, titles, and wealth with William's victory. The Molyneux emblem appears like a rectangular Maltese cross, but, in fact it represents the vanes of a windmill.

Already residing and in command of the great fortress, in 1446 the Molyneuxs were awarded the hereditary constableship of Liverpool Castle by King Henry VI (1421–71). Their fearsome stronghold glowered down over the town, the port, and its people for almost the next three centuries. This overt evidence of their power and wealth made the Molyneux family very unpopular in Liverpool. It also entrenched their rivalry with the town's other aristocratic family, the Stanleys.

The Molyneux family became increasingly dominant in the town and were lords of the manor and holders of the tithe of Liverpool. In the eighteenth century they went on to become the earls of Sefton, with their family seat at Croxteth Hall just to the north-east of Liverpool.

In the early 1980s, Derby Square was being excavated for new law courts. In what appears to have once been a deep cell or dungeon of the castle, the dried and perfectly preserved corpse of a uniformed Roundhead soldier was found. This dated from the Civil War. Had he been imprisoned and left to starve to death? We are unlikely ever to know.

For centuries the castle and its occupiers had subjugated the small town of Liverpool. Its great towers and imposing gateway emphasised to the people where exactly in the land the true power lay. As we shall see, it took the English Civil War to put an end to the castle, which was severely damaged in the final siege on the town, but it was not completely cleared away until 1726. Nothing now remains (above ground) to say that a castle ever stood there except a plaque noting the fact, mounted on the side of an imposing memorial sculptural group. This monument is dedicated to Queen Victoria and was unveiled in 1902.

Buildings now surround Derby Square and, in the cellar under appropriately named Castle Moat House, a large section of the old castle moat survives. In the middle of what is now a surfaced and brick-lined cellar stand the massive columns that support the current building. Also, in the centre of the floor and under a wooden trapdoor, is a short access shaft to a very ancient tunnel. This originally led from the moat to the bottom of the high ridge, at what was once the shoreline of the river. These are the only remnants now of the formidable Liverpool Castle. This stood on another of Liverpool's original seven streets.

But there was one more great, fortified, military stronghold in Liverpool, and this was the property of the Stanley family.

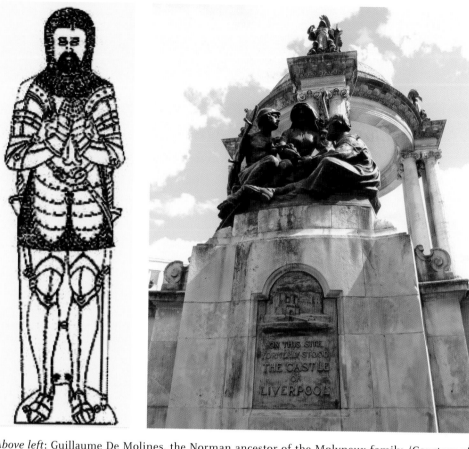

Above left: Guillaume De Molines, the Norman ancestor of the Molyneux family. (Courtesy of Discover Liverpool Library)

Above right: Liverpool Castle plaque on the plinth of the Queen Victoria monument in modern Derby Square. (Courtesy of Discover Liverpool Library)

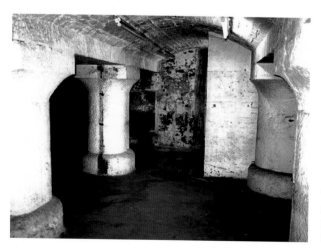

The moat of Liverpool Castle, now the cellars of Victorian buildings. (Courtesy of Discover Liverpool Library)

This is Water Street and it runs from the Town Hall to where the edge of the river once flowed; hence its name. On the northern corner, and from around 1250, stood a large mansion house built directly on what was then the waterfront shoreline.

Constructed in large blocks of local sandstone, by the year 1369 this had become the property of Sir Robert de Lathom (1209–90), who was a very wealthy and powerful local aristocrat. Then, in the reign of Henry IV (1366–1413), the building passed into the hands of Sir John Stanley (1350–1414). This was in 1385, when he married Sir Robert's very wealthy daughter, Isabel de Lathom (1365–1414).

John Stanley was a wealthy gentleman knight in his own right, who already owned estates throughout Lancashire and Cheshire. He was also Lord Lieutenant of Ireland, governing the country in the name of the king. In 1405, Henry also granted Sir John the title of King of the Isle of Man, making him one of the most influential aristocrats in the kingdom.

Sir John had an exceptionally large estate and hall at Lathom, 15 miles north of Liverpool near Ormskirk, and another vast estate and hunting lodge at Knowsley, 8 miles to the east of the town. In 1406, Sir John made an application to the king to be allowed to fortify his riverfront property. Henry gave his permission, so Sir John set about expanding and redesigning the large house, and he renamed it the Tower of Liverpool. This was done to leave the local people and his rivals, the Molyneuxs, in no doubt as to his own status and authority.

Lathom House near Ormskirk was one of the magnificent homes of Sir John Stanley and his wife Isabel de Lathom. (Courtesy of Discover Liverpool Library)

Edwardian postcard depicting Sir John and Lady Isabel Stanley in their grand house at the bottom of Water Street in Liverpool; this would become the Tower of Liverpool. (Courtesy of Discover Liverpool Library)

By 1413, the powerful Stanley family had converted the old mansion into a military stronghold, which was permanently garrisoned by their own troops. These men stood guard over the Stanleys' embarkation point for Ireland and the Isle of Man – at the foot of Water Street. For 250 years the tower remained the Stanley family headquarters in Liverpool. It was also the base from which they governed their 'Kingdom of Man' on the small island in the Irish Sea, as well as Ireland itself.

In addition to its high walls and turrets, battlements, and a formidable, impregnable gateway, the tower also had armouries and other facilities for the soldiers. Also, like the castle, there were dungeons and cells. On the upper floors, however, were much more comfortable apartments for Sir John and his family, and the tower became their town house.

From 1485, the Stanleys became the earls of Derby and grew even more in power and wealth. By 1717, though, the family no longer had any need for the tower and so they sold it. By 1737, the 500-year-old building was being leased from its new owner by

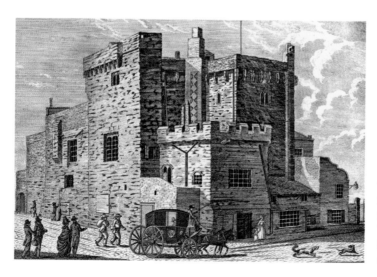

The strong fortress of the Stanleys, which they named 'The Tower of Liverpool'. (Courtesy of Liverpool Athenaeum Library)

Liverpool Corporation. They soon began to employ its noisome cellars and dungeons as an increasingly notorious town gaol, while the upper floors were used as assembly rooms for dancing, gaming, and other entertainments.

Conditions in the prison soon became foul beyond belief for the unfortunate people who found themselves incarcerated there. Men, women, boys, and girls were all herded together with no discrimination, and in often violent, gross, and indecent circumstances. Strong prisoners bullied the weak, while the jailers bullied everyone and extorted money from the prisoners. Cruelty, brutality, abuse, filth, and starvation became facts of life in the tower's dungeons.

There were seven cells, each around 6 feet square and all well below ground level. At least three prisoners could be confined in each of these, with the only light and air entering through a tiny grill above each cell door. There was no water supply or sanitation so disease and death were commonplace. What food was provided was of appalling quality and far from regular. This meant that starving prisoners were often reduced to catching and eating rats, mice, and cockroaches to survive.

The excrement and mud that accumulated could often be ankle-deep, and was only removed (by the prisoners under close guard) when the happy revellers in the Assembly Rooms above could no longer stand the stench. This became especially bad in hot weather. Even then, the mire would only be taken into the centre of one of the tower's two courtyards, where it was piled up in a huge midden that was only removed once a month. These sewage-covered yards were also the only places where the prisoners could get any exercise.

There was a larger cell in the tower on the ground floor. This was big enough to accommodate between ten and twelve people, but at one point it was home to over forty, men, women and children. This did have a high window, which faced out onto the street.

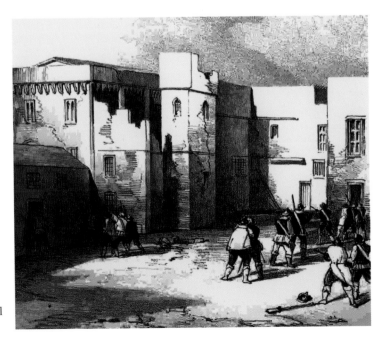

One of the inner courtyards of the Tower of Liverpool. (Courtesy of Liverpool Athenaeum Library)

Through this, and depending on the charity and generosity of the public, the prisoners lowered gloves or bags, tied to strings suspended from sticks. They hoped that kindly passers-by might drop coins or food into these. Sadly, it was a favourite sport of the local boys to deposit stones, mud, or other nasty substances into the begging-bags.

The dreadful Tower of Liverpool was closed in 1811 and demolished soon afterwards, to be replaced by warehouses and then an office block. This too was replaced, in 1906, by the current tall, modern office block named Tower Building. This overlooks the former burial ground of the Church of Our Lady and St Nicholas, and stands exactly on part of the site of the original Tower of Liverpool. However, apart from some of its design features, the present building reveals nothing of the grim yet significant history of the ancient tower, or of Liverpool's medieval military past.

Modern Liverpool stands on seven main hills, but at the time of its founding the tiny new town nestled in a basin between some of these hills and the river. It was overlooked by one of the highest hills, known as Everton Ridge. This was where the small township of Everton had existed since the time of the Romans.

But it was in the middle years of the seventeenth century that Everton played a significant role in the life of Liverpool. In fact, this was about to be the very worst time so far in the history of the small but increasingly important town and port. The citizens would have to fight for their lives – not once, but three times in just a few years. Very many people would lose that fight and the fabric of the town would be catastrophically attacked too.

But Liverpool was not the only place to suffer so dreadfully; the entire country of Britain was about to be torn apart from within rather than by a foreign invader. Ireland too would once again fall prey to the political ambition and religious bigotry of the English.

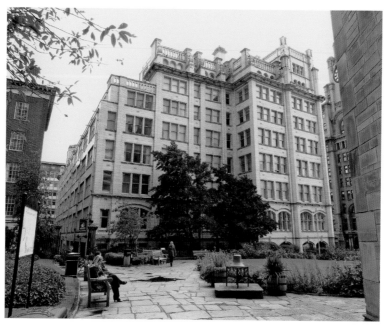

Modern Tower Building stands on the site of the original, and very grim, Tower of Liverpool. (Courtesy of Discover Liverpool Library)

4. The 'Crows Nest'

In July 1642, when civil war in Britain was becoming inevitable, and in common with the rest of Britain, Liverpool was divided. The town's aristocrats, leading citizens and Corporation members were supporters of the king, Charles I (1600–49), and believed in government by a ruling class. His followers and soldiers were generally known as 'Royalists' or 'Cavaliers'. However, the vast majority of the townspeople were strongly in support of the Parliamentarians and in the rights of ordinary people. Their troops were often known as 'Roundheads', because of their short hairstyles.

It was also clear that the strategically positioned town would become a prime target for both sides in the coming conflict. This was because its safe harbour commanded the major sea routes and because of its fortified tower and great castle. The Royalist Mayor of Liverpool, John Walker (dates unknown), saw to the defences of the town. He worked closely with Lord Richard Molyneux (1619–54), 2nd Viscount, and James Stanley (1607–51), Lord Strange, the eldest son of the 6th Earl of Derby.

A large store of arms and gunpowder was stored in the dungeons of the castle, and a great defensive rampart was built encircling the town. However, only too aware of their unpopularity with the ordinary people of Liverpool (and with many of the local civic leaders, including the Earl of Derby), the Molyneuxs saw this as an opportunity to secure their position. So, on 25th August 1642, when King Charles raised his standard at Nottingham and the war began in earnest, Lord Molyneux encouraged the Royalists to take control of Liverpool and its castle, which they did.

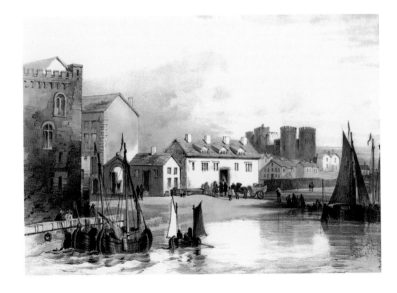

Liverpool town before the outbreak of the English Civil War. (Courtesy of Discover Liverpool Library)

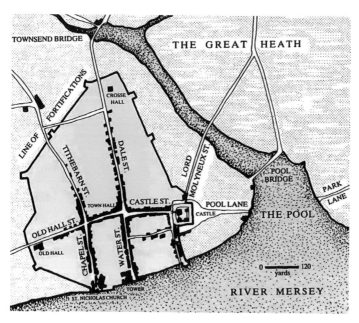

Map of
seventeenth-century
Liverpool showing the
defensive wall that
surrounded the small
town and its seven
streets. (Courtesy
of Liverpool City
Record Office)

By September, Lord Strange had succeeded as the 7th Earl of Derby on the death of his father. A small group of his loyal retainers stayed in the Tower of Liverpool while he left the town to fight in support of the king. Meanwhile, Lord Richard Molyneux also left to defend nearby towns from Roundhead attacks, including Warrington and Wigan. However, he was pursued by Parliamentarian forces under the command of Colonel Ralph Assheton (1596–1650). This formidable soldier was commander-in-chief of all Parliamentary forces in Lancashire.

In April 1643, while Lord Molyneux had found safe refuge on the Wirral, Assheton attacked and besieged Liverpool with an army of 1,600 men. The Royalists in the town were under the command of Colonel Sir Thomas Tyldesley (1612–51), who was very wealthy and a staunch Roman Catholic in the Protestant-dominated town. He suddenly found his positions under a cannonade from the tower of the Church of Our Lady and St Nicholas. Parliamentarian soldiers had captured and armed this after entering the town from the river, where the church stood at the end of Chapel Street.

Tyldesley soon proposed terms of surrender, but Colonel Asheton rejected these and immediately began an all-out assault on the defenders. He was victorious, driving Tyldesley and his Royalists out of the town, killing eighty of them and taking over 300 prisoners. He also captured ten cannon, all with the loss of only seven Parliamentarian lives. Royalist-held Liverpool now passed into the hands of the Parliamentarians and their Roundhead troops.

However, some Royalist sympathisers escaped from Liverpool to other communities outside its boundaries. Many made their way to the Royalist stronghold in the nearby village of Everton. This overlooked the town high on Everton Ridge. A small handful of other supporters of the king stayed within the town, including Lord Molyneux's younger brother Caryll (1622–99), who would become 3rd Viscount Molyneux. The Molyneuxs

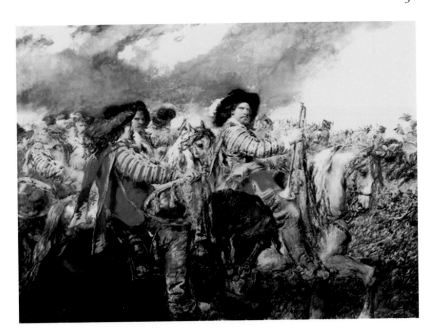

Defeated
Royalists.

were also Roman Catholic – another reason why they were so disliked in the town. Caryll stayed inside the castle with a small cohort of his personal supporters, trying to draw as little attention to themselves as possible.

Liverpool was now garrisoned for Parliament under the command of Colonel John Moore (1599–1650), a member of a prominent local merchant family. The ordinary people of the town were now eager for the civil freedoms offered by the opponents of the monarch. Perhaps this was an early demonstration of the militancy of later generations of Liverpudlians! However, they knew only too well that an attempt to retake their town was inevitable, and around half of them took this opportunity to leave with their families and belongings. This left around 1,000 men, women, and children now preparing to fend off another siege and assault. It was only a matter of weeks before this began.

In May 1644, Prince Rupert of the Rhine (1619–82), the twenty-four-year-old nephew of Charles I, marched his troops towards Liverpool to recapture it for the king. This was at the urging of Earl James Stanley and with the encouragement of the Molyneuxs. Arriving on the evening of 1 June, the young German prince chose to plan his attack from Everton. This was not only because the high ridge afforded a magnificent overview of the town, but also because of its Royalist loyalties. It was also home to Catholic priests who had previously been expelled from Liverpool by the town's dominant Puritans.

Rupert was by this time an experienced and already successful military commander, and he seized a large cottage in the heart of the village. This was a long, low, stone building with a thatched roof. It had four rooms with clay floors and stood on an escarpment of rock just to the north of the village green, giving unobstructed views of the valley and the town of Liverpool below. The prince set up home here and established it as his military headquarters. Afterwards, this was always known as 'Prince Rupert's Cottage', until its demolition in the eighteenth century.

Left: The nephew of Charles I, Prince Rupert of the Rhine, who besieged Liverpool with 10,000 troops.

Below: Prince Rupert commandeered this cottage in Everton Village to use as his headquarters during the siege of Liverpool. (Courtesy of Liverpool Athenaeum Library)

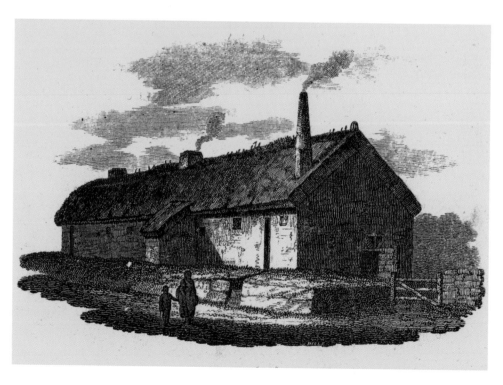

With him, the Royalist commander had brought his pet spaniel and his tame monkey on a jewelled lead; both animals accompanied him everywhere. However, Rupert had also brought with him an army of 10,000 soldiers and cavalry to attack the town, well-supported by cannon and armaments. His men camped with their horses, munitions, and supplies on land towards the rear of the broad ridge, on what is now Heyworth Street.

By this time, news of the swathe of violence that Rupert had already cut through Lancashire had reached Liverpool, especially the vivid descriptions of his brutal massacre of the people of the town of Bolton. The arrival of Rupert's forces on Everton Ridge had therefore struck terror into the inhabitants of Liverpool. For safety, most of the women and children of the town had been immediately sent across the Mersey to Storeton Hill, on the Wirral, where there was an armed Roundhead camp to protect them.

About to be besieged for the second time in the war, the town's defenders strengthened their perimeter wall and, in places, they dug a deep ditch in front of it – 12 yards wide and 3 yards deep. They also placed batteries of mortars along the town side of the creek that fed the Pool, especially at the end of Dale Street – another of the seven streets. A number of cannon were also mounted on the castle towers and battlements. In addition, they positioned another formidable battery of mortars at the entrance to the Pool harbour.

Between 400 and 500 men and youths now remained in the town, and they armed themselves fully with muskets and pikes, ready to die in defence of their homes. But all of this was known to Prince Rupert, because Caryll Molyneux's 'fifth column' inside the castle had been smuggling messages out to him.

Consequently, the rash young man believed that taking the town would be a simple matter. Indeed, gazing down on the town from his Everton vantage point, he declared that Liverpool was 'nought but a crows' nest that a parcel of boys could take'. So, on 7 June 1644, Prince Rupert began his siege. He must have quickly regretted his initial brashness because his guns could not reach the town from Everton and so he had to reposition his batteries in trenches much nearer to his target. He did so along the line of what is now Lime Street.

A massive cannon assault was mounted on the town, from where Lime Street now runs.

His cannon were arrayed from where the Wellington Column today dominates William Brown Street, to a point now occupied by the Adelphi Hotel. Firing over the broad creek running to the east of the small town, and above its outlying mills, farmsteads, and cottages, Rupert bombarded Liverpool. Although subjecting the people to a virtually constant barrage of artillery, which lasted for around ten days, he killed only forty of the defenders. The arrogant German prince was soon to discover – to his cost – that the resistance mounted by the townspeople was considerable and determined. In his continuous cannonade against the town Rupert had been forced to use over 100 barrels of gunpowder. He had also lost 1,500 of his men in the returned fire from the embattled but fierce Liverpudlians.

His losses only stiffened Rupert's resolve and, on 16 June, he ordered a secret night-time attack that was aided by the Royalist sympathisers in the town, led by Caryll Molyneux. Molyneux's men had sneaked up another of the seven streets, Old Hall Street, past Colonel Moore's family mansion. In the dead of night they had treacherously breached the town's defensive walls from within. The men took down the large woolpacks that made up the bulk of the rampart, and used these to fill in the defensive ditch so that the troops could cross. Meanwhile, Rupert's army had silently made their way down from Everton and were hiding under the eaves of the Kirkdale Forest, just a few hundred yards to the north of the town wall.

Prince Rupert and Sir Caryll Molyneux massacred the inhabitants of Liverpool in 1644.

On getting a signal from the traitors, and with Caryll Molyneux now at his side, Rupert led his troops through the wide gap in the wall and they poured into Liverpool. Their attack was swift and exceptionally brutal. In a bloody massacre the prince's men put everyone they encountered to the sword. Colonel Moore had put up a serious defence, but when he realised that his defeat was inevitable, he escaped to sea from the Pool.

Once the battle was over and all resistance had been quashed, Rupert ordered the complete sacking and burning of the town. It was plundered of all its gunpowder and shot, as well as its money, gold, and treasures, and was left in smoking ruins. Liverpool Tower was untouched because it belonged to Lord Derby. The castle too, although it had sustained some damage from the bombardment, was not destroyed. This was not just out of consideration for the Molyneuxs, but also because it remained a strategic stronghold.

During the siege and the subsequent sacking of Liverpool it is estimated that around 400 townsfolk lost their lives. The town records report that of these were 'some that had never borne arms ... yea, even one poor blind man'. The books of the Moore family describe how their 'Old Hall' was ransacked and plundered for portable valuables. These also state that, 'the outhouses of the Old Hall were pulled down when Prince Rupert took Liverpool ... putting all to the sword for many hours, giving no quarter; where Caryll, that is now Lord Molyneux, killed seven or eight men with his own hands; good Lord, deliver us from the cruelty of blood-thirsty papists. Amen'.

It would be six months later before the surviving men and the returning women and children had finished properly burying their dead. A later entry in the town records, dated 20 January 1645, reads, 'We find that a great company of our inhabitants were murthered and slain by Prince Rupert's forces; the names of the murthered we cannot yet be certified of; any of them or their names.'

James, 7th Earl of Derby, whose Tower of Liverpool suffered little damage during the English Civil War. (Courtesy of Discover Liverpool Library)

Following his victory Rupert had taken up lodgings in the castle, but he only stayed in the town for nine nights before moving on to York, on the orders of the king. The prince left the town garrisoned by English and Irish troops under the command of Sir Robert Byron (dates unknown), and he joined Charles I in the Battle of Marston Moor. Here, on 2 July 1644, the Royalists suffered a crushing defeat.

The war was not going well for the armies of the monarch locally either and on 20 August Royalist troops were defeated again, this time at nearby Ormskirk. They retreated in disarray to Liverpool, where they joined the existing Royalist occupiers. However, the Roundheads were in hot pursuit. Now under the leadership of Major-General Sir John Meldrum (d. 1645), they soon laid siege to Liverpool from the north and east. Meanwhile, the previously defeated Parliamentarian governor of the town, Colonel Moore, attacked Liverpool from the river and the mouth of the Pool.

What was now the third siege of Liverpool began immediately and lasted until 4 November. The Royalists had now all withdrawn to the relative protection of the castle and its adjacent buildings, but the old bastion became the main target of the relentless bombardment, and it was soon severely damaged. Before long the exhausted garrison could take no more and they mutinied against their officers, surrendering the town to the now victorious Parliamentarians. Fortunately for the defeated soldiers, the victorious Roundheads were more humane in their triumph than the Royalists had been in theirs, and the lives of the captured officers were spared. They were also allowed to retreat in safety to Ireland.

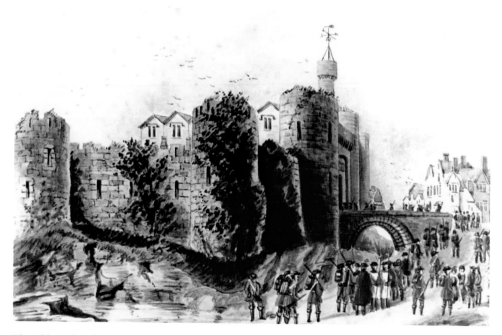

The old castle of Liverpool was severely damaged during repeated bombardments of the town. (Courtesy of Liverpool Athenaeum Library)

After this final assault the war-ravaged town and its damaged castle remained in the hands of the Parliamentarians. Indeed, the damage to Liverpool was so significant that the following year, on 17 September 1645, the surviving townsfolk presented a petition to Parliament, pleading for financial compensation. The response was speedy and included an order for direct reparation to be made from the local estates of Royalist supporters.

The town received £10,000, with a further £20 for 'the relief, if it be possible, for poor widows and fatherless children that had their husbands and fathers slain, and their goods plundered, and others in the town who are in distress and want.' Also, in 1646, the town records state, 'that the castle bee repaired and fortified', showing that money had also been received to repair the considerable damage done to the building during the three sieges.

On 1 January 1649, Charles I was put on trial by Parliament accused of being 'a tyrant, traitor and murderer; and a public and implacable enemy to the Commonwealth of England'. It was also charged that he, 'out of a wicked design to erect and uphold in himself an unlimited and tyrannical power to rule according to his will, and to overthrow the rights and liberties of the people of England'. Inevitably, he was found guilty and was publicly beheaded on 30 January 1649. In fact, Liverpool's former governor, Colonel John Moore, was one of the 'Regicides' – a signatory on the king's death warrant.

James Stanley, 7th Earl of Derby, was also captured, and was himself beheaded by the Puritans at Bolton on 15 October 1651. He went to his death with great dignity and heroism, which began to soften the attitude of the Liverpool townsfolk towards his family. This meant that the Stanleys soon won their way back into favour in the town – not so the Molyneuxs!

In the conflict over half of Liverpool's population had been killed and many wounded or maimed. Following the massive loss and destruction of land and property the people of the town held the Molyneux family directly responsible for their tragic condition.

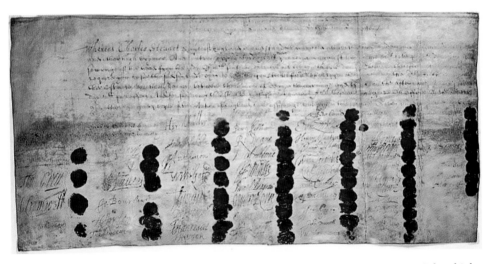

Death warrant of Charles I. One of the signatories was Liverpool's former governor, Colonel John Moore. (Courtesy of Discover Liverpool Library)

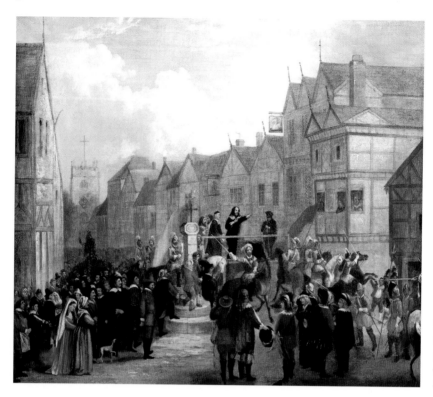

Execution of the 7th Earl of Derby, at Bolton.

The memory too of the personal cruelty and treachery of Caryll Molyneux lived long in the hearts of Liverpudlians. The family now quietly withdrew to their Croxteth estates well to the east of the town.

The Civil War left social and political scars on Britain that would take decades, in some cases centuries, to heal. The loss of life had been catastrophic. Indeed, proportionally, more British people died in the Civil War than in any other conflict, including those of the twentieth century. In the seven years that the war lasted, one in ten British people were killed – 85,000 on the battlefields and another 100,000 dying of their wounds. In percentage of population terms, this was three times more than those British killed in the First World War and five times more than those killed in the Second World War. Additionally, it is estimated that, after the English Civil War, the military campaigns waged in Ireland by the Roundhead troops of Oliver Cromwell (1599–1658) to subjugate those people, resulted in around half the Irish population being wiped out.

But, for Liverpool, the destruction of their town was soon repaired, as former residents returned and as new people moved in. However, the events that had taken place during the war in and around the town were to play a significant role in the development of the unique psyche of Liverpool people. This is particularly true of their 'belligerent independence' and unwillingness to easily submit to authority or government. It was also the Civil War that fuelled the peculiar pride that Liverpudlians have in being members of a closely knit community. To this day they remain fiercely determined to protect their civil and economic rights and autonomies.

This resolve now fuelled Liverpool's post-war recovery. Trade, in a wide range of commodities, began to burgeon once again as the volume of shipping on the river rapidly increased. The tidal harbour of the Pool of Liverpool provided the anchorage that an increasing number of merchants needed, especially as maritime commerce with the 'new world' of the Caribbean and the Americas also began to grow.

In 1715, the Pool that had generated the founding of the town was reclaimed, enlarged, and converted into the world's first, enclosed, commercial wet dock. Liverpool's docklands, maritime trade, wealth, population, and strategic importance soon began to grow at an exponential rate.

The Civil War was, however, the last time that Liverpool was ever besieged and captured by her enemies, although others over the centuries would still attempt to do so.

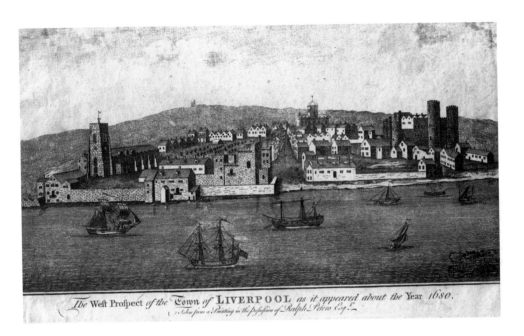

The West Prospect of the Town of LIVERPOOL as it appeared about the Year 1680.
Taken from a Painting in the possession of Ralph Peters Esq.

Above: Liverpool soon began to recover in the decades immediately following the catastrophe of the English Civil War. (Courtesy of Liverpool Athenaeum Library)

Right: Liverpool's, and the world's, first commercial wet dock opened in 1715. (Courtesy of Liverpool Athenaeum Library)

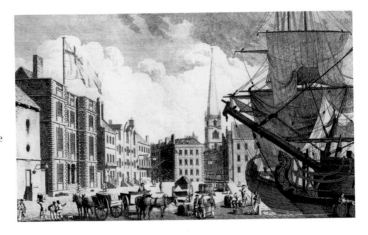

5. 'The Fifteen' and 'The Forty-Five'

In 1685, the Stuart king, Charles II (b. 1630) died, but not before converting to Catholicism on his deathbed. Without a legitimate heir, although Charles had plenty of illegitimate children, the thrones of England, Scotland, and Ireland were inherited by his brother who now became King James II (1633–1701).

In 1669, James had also converted to Catholicism, but this had not prevented his succession, although some in the country were concerned by his faith and by his attempts to install fellow Catholics in influential positions. One such Protestant rebel was Charles II's illegitimate son, the Duke of Monmouth (1649–85). He raised an army and marched from Scotland to overthrow the king and claim the crown for himself. This was speedily quashed, and Monmouth was brutally and inefficiently beheaded.

Then, in 1688, King James had a son, James Francis Edward Stuart (d. 1766), which convinced other Protestant Nobles that a Catholic succession was about to be imposed on them. They invited a Protestant prince from the Netherlands, William of Orange (1650–1702), to take the throne. In what became known as the Glorious Revolution, William landed in Devon with an army whilst King James had assembled a force of troops

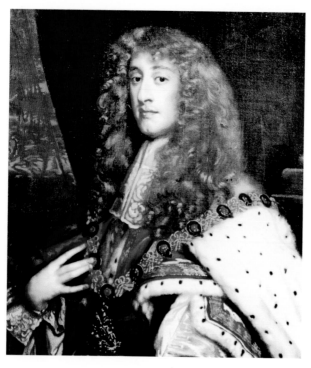

James II.

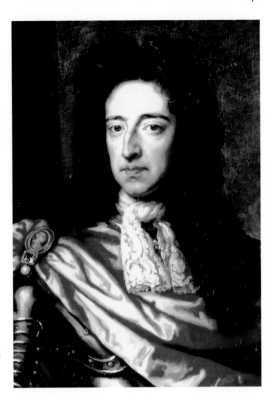

William III of Orange was invited to take the throne by the English government because he was Protestant.

to defend his thrones. However, James's army and navy deserted him, forcing him to flee abroad. William of Orange and his wife Mary (1662–94), who was the legitimate daughter of James II, were crowned joint monarchs that same year.

William and Mary were succeeded by the Protestant Queen Anne (1665–1714), another legitimate daughter of James II. She was followed on the throne by Protestant kings, George I (1660–1727) and then by George II (1683–1760). However, each of these monarchs had to deal with rebellions from members of the exiled Stuart dynasty, each determined to reclaim the English throne for their family and rule as Catholics.

These uprisings were known as the Jacobite Rebellions, taking their name from 'Jacobus', the Latin form of 'James'. One of the most significant of the rebellions took place in 1715, so became known as 'The Fifteen'. This was led by James Francis Edward Stuart who later became known as the 'Old Pretender'.

Coming to Scotland from his place of exile in France James soon found his rebellion collapsing almost as soon as it had started. This was despite some ferocious fighting between rebel and government troops. The Jacobites suffered major defeats at the battles of Preston and Sheriffmuir, and many rebels were slaughtered. James abandoned his lost cause, leaving England for France again, never to return. A number of rebels were executed, others were deported, peerages were forfeited, and Scottish clans were disarmed.

After The Fifteen had finally been put down, captured Jacobites were held prisoner in the ancient gaols of Lancaster, Preston, Chester and in the unwholesome dungeons of the Tower of Liverpool.

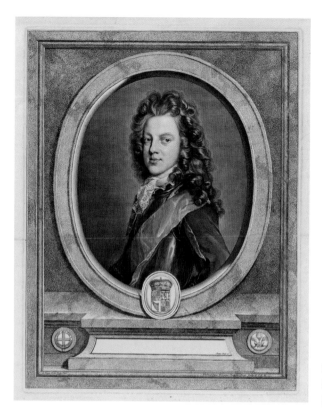

Prince James Francis Edward
Stuart, the 'Old Pretender'.
(Courtesy of Rijksmuseum)

Between 20 January and 9 February 1716, a specially convened court was held in Liverpool to try seventy-four Jacobites for high treason; sixty of them were found guilty. Of those men who had admitted their offence, many avoided the death penalty. Some were transported, while others were imprisoned. But their prison conditions were so harsh that many of them died anyway of disease or malnutrition. In total, thirty-four men were sentenced to be executed in various towns around the north-west as an example and a deterrent. And what a grisly end it was to be: the traitors' death by hanging, drawing and quartering.

This evil and sadistic form of execution had been invented in 1241, specifically to punish a man called William Maurice who had been convicted of piracy. In 1283, Dafydd ap Gruffydd, the last Welsh prince of Wales (born *c.* 1235) also died this way, as did William Wallace (*c.* 1270–1305), 'Braveheart', at Smithfield in London. Guy Fawkes and his fellow Gunpowder Plot conspirators had also been victims of this terrible punishment in 1606, but now it was the turn of the Jacobite rebels.

On 25 February 1716, four terrified prisoners, whom records list as 'Archibald Burnett, Alexander Drummond, George Collingwood, and John Hunter,' were dragged from the dungeons of the Tower of Liverpool where they had been held. They were tied to a type of sled and horses pulled this through the streets of the town to its outskirts. Here, near three windmills, a specially constructed scaffold platform with a gallows had been erected.

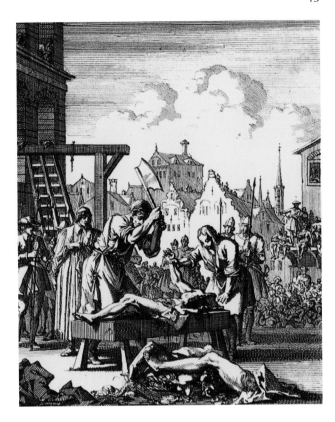

Grisly execution by hanging,
drawing and quartering.

Then, in front of a very large crowd, the condemned men faced their executioners. This complex penalty required a number of such professionals to carry it out, who were paid £10 and 3s for their work. With the last of the prisoners forced to witness the other three die before him, in turn, the gruesome process began.

First, the victim was stripped naked and hanged by the neck from the gallows, slowly strangling. Then, and just before death, he was taken down, stretched spread-eagled on the scaffold platform and tied down by his wrists and ankles. His genitals were then hacked off and burned in a fire in front of his eyes. Next, his belly was slit open and his intestines were slowly pulled out of him, or 'drawn'. These too were then burned before his eyes.

Only when this process was complete would the screaming man, awash with his own blood, be put out of his anguish by having his head slowly sawn off. His mutilated body was then cut into four quarters, each one to be displayed on a pike in a different town in the region – again, as an example and deterrent.

Despite this dreadful retribution the supporters of the exiled Stuart royal family were not deterred and in 1719 another revolt began in Scotland, but this was quickly crushed. Then, in 1745, they mounted another, much larger armed rebellion. What now became known as the 'Forty-Five' was led by the son of the Old Pretender. This was Charles Edward Stuart (1720–88), the 'Young Pretender' but better known to history as 'Bonnie Prince Charlie'. The twenty-five-year-old would have much greater success in his uprising than his father had experienced – up to a point.

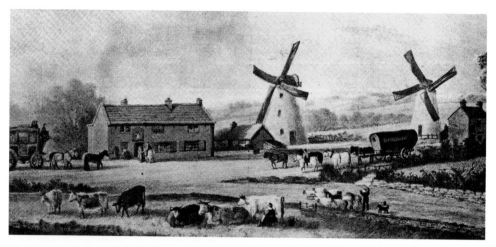

The Gallows Mill once stood on London Road, and was built on the site of the scaffold and gallows where the Jacobite rebels were executed in 1716. (Courtesy of Liverpool Athenaeum Library)

During the Fifteen, Liverpool town had not been directly threatened by the rebel army. This time, though, its people were genuinely concerned for their safety. Sailing to Scotland from France, also his place of exile, Charles raised the Jacobite standard at Glenfinnan in the Scottish Highlands, where he was supported by a gathering of Highland clansmen. They first marched towards Edinburgh where they were victorious at the Battle of Prestonpans. Confident of further victories they crossed the border into England. Their ultimate goal was the capture and surrender of the government in London.

Making their way first to Carlisle, which they successfully captured, the Jacobites then continued deeper into the north-west, heading towards Liverpool. Panic spread before them, except in the town, which was staunchly Georgian. Here the people were ready and eager to repel the rebels and defend themselves. An enthusiastic volunteer infantry force of over 2,000 men was mustered from the town, funded by the Liverpool Corporation and a public subscription totalling £1,000.

Officially named the 79th Regiment of Foot (Royal Liverpool Volunteers), they were kitted out with smart new hats, blue coats, stockings and shoes, and became known as the 'Liverpool Blues'. On 15 November 1745, eight companies of 'Blues' marched towards Warrington. Here they broke down bridges across the Mersey to halt any advance by rebel troops.

Despite the town's fears, however, Bonnie Prince Charlie carefully avoided Liverpool, but he did get as far as Derby. Joining with other regiments the Blues fought victoriously on the side of the king against the Young Pretender and he was driven all the way back towards Scotland again. Indeed, in early December 1745, the Blues helped in the siege and recapture of Carlisle Castle. This had been held by Scots rebels until they surrendered to the loyalist army on 30 December.

In acknowledgment of their loyalty and courage, the Liverpool troops received the honour of a royal inspection by their commander, Prince William Augustus, Duke of Cumberland (1721–65), the son of George II. To acknowledge and reciprocate this honour,

Above: Cartoon of Bonnie Prince Charlie satirising his procession. (Courtesy of Rijksmuseum)

Right: The Duke of Cumberland, who commanded the Liverpool Blues, but was also 'The Butcher of Culloden'.

the town of Liverpool laid out new streets and named them after the duke: Hanover, Duke, and Cumberland streets, each of which still exist.

It was near Inverness that the final battle of the Jacobite Rebellion was fought. This was also the last battle ever fought on British soil, and it took place at the moor known as Culloden on 16 April 1746. Here, Bonnie Prince Charlie led an army made up of a number of Scottish clans, totalling around 6,000 men. These were attacked by 8,000 king's troops under the command of the Duke of Cumberland.

The loyalists won the battle but offered little mercy to the rebels, with between 1,500 and 2,000 Scotsmen being slaughtered, wounded, or captured. The Duke of Cumberland became known as the 'Butcher of Culloden' because of his ruthlessness on the battlefield. Bonnie Prince Charlie had fled the battlefield when defeat became inevitable and wandered around the Highlands of Scotland for around five months during the summer of 1746. He soon returned to France and permanent exile where, largely forgotten, he died.

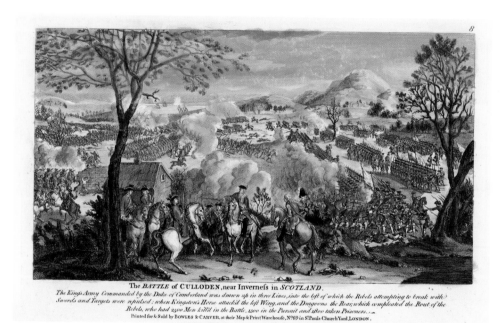

The Battle of Culloden, 1746. (Courtesy of Yale Center for British Art)

6. Profitable Enemies All

Between 1756 and 1763, Britain was embroiled in the Seven Years' War. This involved every European great power of the time and was fought across Europe, the Americas, West Africa, India, and the Philippines. On one side, and led by Britain, were Prussia, Portugal, Hanover, and other small German states. On the opposite side were France and her allies: the Austrian-led Holy Roman Empire, the Russian Empire, Bourbon Spain, and Sweden.

The Liverpool Blues had been disbanded after the Jacobite Rebellions, but volunteers from the town had fought with the British Army in this major conflict. Then, between 1775 and 1782, the Royal Navy and the British Army were now fighting Americans who were waging their Revolutionary War of Independence against Britain. The French and the Spanish were fighting on the side of the Americans, who successfully gained their freedom from British rule.

During this war, in 1778, and at the expense of the town, the 79th Regiment of Foot (the Liverpool Blues) was reformed. An infantry regiment who now fought as marines, the Liverpudlians arrived in Jamaica in 1779. They also served in the Spanish colony of

British troops besieging Charleston in 1780, during the American War of Independence.

Nicaragua, and were transported there by a ship under the command of a young Captain Horatio Nelson (1758–1805). The regiment returned to Liverpool in early 1784, where it was finally disbanded, following Britain's defeat.

In 1797, news arrived in Liverpool that the French were mustering to invade England. Within only a day an enthusiastic, wealthy, successful merchant and enthusiastic ex-soldier by the name of Edward Falkner (dates unknown), had recruited a thousand local fighting men. He armed, equipped and uniformed them largely at his own expense. Very soon they were ready not only to defend Britain but to immediately embark for France and to overwhelm any invasion force that they found there.

When the French government heard what Falkner had done, and in how short a space of time, they took this as a clear indication of British determination and military strength, and instantly cancelled their invasion plans. This meant, of course, that Liverpudlians had saved Britain from invading Frenchmen. Falkner became a local and national celebrity.

However, French ambitions for conquest revived, and so from 1799 to 1815 the British took it upon themselves to thwart these once and for all. The French were under the command of the self-appointed French emperor, Napoleon Bonaparte (1769–1821), in what became known as the Napoleonic Wars. The British Navy and Army in particular battled the French, but at various times they fought in coalition with the Austrian Empire,

Falkner Square, named after Colonel Edward Falkner whose volunteer troops deterred the French from attacking England. (Courtesy of Discover Liverpool Library)

the Kingdom of Prussia, the Kingdom of Spain, the Kingdoms of Naples and Sicily, the Kingdom of Sardinia, the Dutch Republic, the Russian Empire, the Ottoman Empire, the Kingdom of Portugal, the Kingdom of Sweden, and with various confederations of Rhine and Italian states. Napoleon was finally defeated by the Duke of Wellington at the Battle of Waterloo in 1815.

Young Liverpool men volunteered, fought and many died in all of these wars, on battlefields across Europe and around the world.

Because of its strategic importance Liverpool was frequently at very real risk of attack, invasion, capture, and occupation by Britain's enemy nations, especially the French, the Spanish, the Dutch, and the Americans. To protect the town and port, and its ships both at anchor and at sail, the waterfront was armed by ranks of cannon. As indeed was the churchyard of Our Lady and St Nicholas Church at the bottom of Chapel Street. Also, armed forts were built at the mouth of the river, on both sides.

Over the years these included, on the Liverpool side, Crosby Point Battery, Seaforth Battery, and the North Fort. On the Wirral side were Liscard Battery and Fort Perch Rock. These were each well equipped with cannon and mortars, and garrisoned with a heavily armed and well-supplied militia made up of many hundreds of fervent local volunteers.

Emperor Napoleon Bonaparte. (Courtesy of Rijksmuseum)

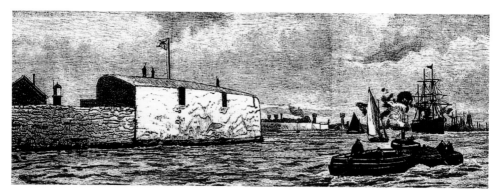

From the late eighteenth century, North Fort guarded the entrance to the Liverpool docks from where Princes Dock now stands. (Courtesy of Liverpool Athenaeum Library)

Fort Perch Rock, built off-shore from the Wirral town of New Brighton, in 1825. (Courtesy of Discover Liverpool Library)

Liverpool also maintained magazines permanently and fully stocked with shot, shell, and powder, but in the event the town and its port were not attacked by Britain's enemies – at least not then. In later wars existing batteries were modernised and new ones built, both on and off-shore, because Liverpool's strategic importance only increased over the centuries.

While Liverpool men were always ready to defend their homes and property on shore, and many joined the British Army to fight overseas, very few seafarers from the town were ever crewmen on warships of the Royal Navy. This was because conditions aboard British vessels were appalling and brutal, and Liverpool has never been a Naval port. In fact, the only way that the British Navy could get recruits from the town was to 'impress' or force them into service at sea.

The Admiralty paid gangs of brutal, burly, government-sanctioned thugs to frequently arrive in the port and then attack and abduct any able-bodied men, whether sailors or not.

Edwardian postcard showing the press gang in wait for an unsuspecting victim. (Courtesy of Discover Liverpool Library)

Operating from 1664 to 1815, and known as the Press Gang, these were the scourge of the Liverpool waterfront and docksides. The Press Gang targeted Liverpool because there were always many hundreds of sailors wandering the wharves and streets, and these were ready-pickings. To resist them could mean imprisonment or death.

However, even though Liverpool may not have been militarily involved in any of Britain's wars at sea, its shipowners and their crews profited considerably from the country's conflicts.

Seafaring Liverpool comprised independent, private sailors paid by the voyage to crew merchant trading vessels and on ships known as 'privateers'. These large, often purpose-built, heavily armed ships (often carrying as many as 120 cannon), were owned by equally independent, private individuals or companies. These had been granted a letter of marque by the British Admiralty, which gave captains authority to 'apprehend, seize, and take the ships, vessels, and goods' of the nation or nations with which Great Britain was currently at war.

Throughout the seventeenth and eighteenth centuries, and until the system was abolished in 1856, Liverpool made a great deal of money from such vessels. The series of violent clashes in which Britain was involved during this long period meant that there were many enemy countries whose ships Liverpool privateers could target. All of these foreign vessels and their cargoes were considered fair game for capture and seizure.

Hundreds of the port's ships took a very active part in this form of legalised, government-sanctioned 'piracy'. This generated considerable profit for their captains, owners, and their crews once a percentage had been paid to the government. They then spent much of that money in the town and paid anchorage fees and customs duty as well. So, all of Liverpool profited from the privateers. Indeed, it was said that 'there was scarcely a man, woman, or child in Liverpool, of any standing, that did not hold a share in one of these ships.'

The Royal Navy were heroes to the townspeople of Liverpool and to the captains and crews of the privateers and ordinary merchant vessels, even if men did not willingly want to sail with them. This was because the Navy supported and defended the town's

Edwardian postcard depicting Liverpool privateersmen aboard their ship, with a target vessel in view. (Courtesy of Discover Liverpool Library)

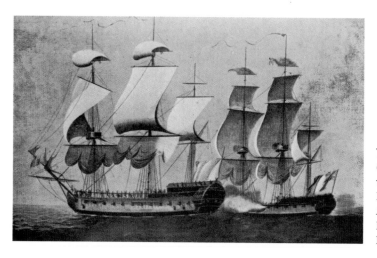

The French ship *Carnatic* captured as a very rich prize by the Liverpool privateer, *Mentor.* (Courtesy of Liverpool Athenaeum Library)

privateers and merchant ships. This allowed commerce to flourish, especially from the slave trade for which Liverpool was infamous. However, one British sailor above all others was the particular hero of the town: Admiral Lord Horatio Nelson. The admiral was never an outspoken supporter of the dreadful trade in humanity, but he was ambivalent about it, stating, 'Liverpool's business is Liverpool's business alone'.

To pay tribute to his recent victory at the Battle of the Nile in 1798, the town conferred the Freedom of the Borough upon the great sailor while he was away at sea. Nelson wrote back in acknowledgement, 'I was taught to appreciate the value of our West India possessions, nor shall their interests be infringed while I have an arm to fight in their defence.'

This somewhat wry comment was no doubt an allusion to the fact that the great seafarer had already lost one arm in defence of British possessions and territory, as well as an eye! Early in 1805, and as another mark of their appreciation for the English admiral, the merchants and Corporation of Liverpool had commissioned the forging

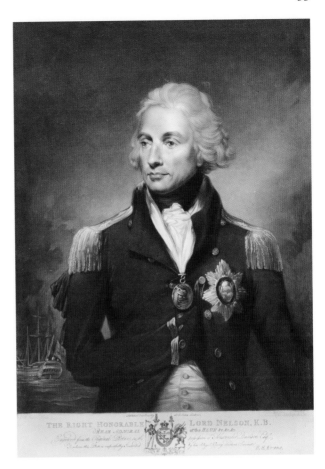

Admiral Lord Horatio Nelson, a hero to the seafarers and citizens of Liverpool. (Courtesy of Yale Center for British Art)

of a ceremonial sword. They invited Nelson to receive this at a formal presentation in Liverpool. However, he was unable to accept the invitation because he was killed in battle before this event could take place.

Nevertheless, in theory the sword is still Nelson's and it remains in Liverpool. It takes pride of place in a display cabinet of city treasures in the Town Hall; however, this was not the only tribute paid to Nelson by the town.

Directly behind Liverpool's Town Hall is an open piazza known as Exchange Flags. This was where cotton and other commodities were once traded in the open air. In fact, on a visit to Liverpool in 1851, and standing on the rear balcony of the imposing civic building, Queen Victoria (1819–1901) looked out over the Exchange at the height of trading. She stated that she had 'never before, in one place, seen such a collection of well-dressed gentlemen'.

In the centre of this open square stands a glorious monument. This commemorates the British Navy's victory over the French and Spanish fleets during the Napoleonic Wars at the Battle of Trafalgar off the Spanish coast on 21 October 1805. But, the impressive sculpture is specifically dedicated to Nelson, who was the commander of the British fleet at that time.

Left: The author with Lord Nelson's Sword, in Liverpool Town Hall. (Courtesy of Discover Liverpool Library)

Below: Cotton traders on Exchange Flags behind Liverpool Town Hall. (Courtesy of Liverpool Athenaeum Library)

This sea battle was one of Britain's most significant naval victories. Indeed, the British Navy lost no ships of the line at Trafalgar, while the Spanish and the French lost all but ten of theirs. The French and Spanish also lost 4,408 of their men, while the British lost only 449. However, one of these victims was Admiral Nelson himself.

This tragedy occurred just at the moment of the naval hero's greatest triumph, as he stood on the deck of his flagship, HMS *Victory*, accompanied by the Captain of Victory, Thomas Masterman Hardy (1763–1839). As the battle reached its climax, just after 1 p.m., Hardy turned to speak to Nelson but found him kneeling on the deck. He was holding himself upright with his hand before collapsing. Hardy rushed to his admiral and close friend, at which point Nelson smiled up at him and said, 'Hardy, I do believe they have done it at last ... my backbone is shot through.'

Nelson had been shot and fatally wounded from a distance of 50 feet by a sniper positioned high in the rigging of the enemy vessel *Redoubtable*. The bullet had entered the great sailor's left shoulder, passed through his spine and had lodged below his right shoulder blade in the muscles of his back. Nelson was carried below decks, where he later died. Nevertheless, the success of the British at Trafalgar foiled France's ambitions for naval domination and their planned invasion of Britain, particularly Liverpool.

As the centrepiece of the sculpture is a group of large, bronze figures. Dominating these is a discreetly naked Horatio Nelson being guided by the goddess of Victory from life, through death and into eternal glory. The skeletal figure of death is seen half-hidden beneath a draped flag, trying but failing to keep a grasp on the great sailor.

Around the plinth of the statue are placed a set of four bronze plaques, showing scenes from some of Nelson's engagements, and by the words of Nelson's famous signal to his fleet at Trafalgar: 'England expects that every man will do his duty.'

Perhaps the monument's most powerful images, however, are positioned above the plaques and are the four seated and chained, naked, life-size male captives, each racked

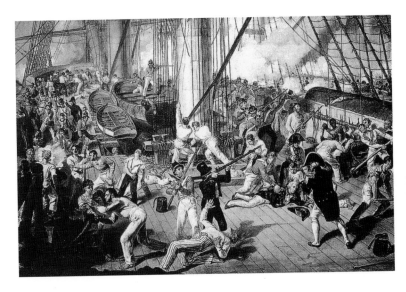

Nelson falls mortally wounded on the deck of his flagship, HMS *Victory*. It would take him three hours to die.

The Nelson memorial sculpture group in Exchange Flags. (Courtesy of Discover Liverpool Library)

by anguish. These are not slaves, as is often mistakenly believed, but symbols of Nelson's four great naval victories – at Cape St Vincent, the Nile at Aboukir Bay, Copenhagen and, of course, at Trafalgar. Indeed, around 4,000 French prisoners of war were held in the borough gaol in Liverpool during the Napoleonic Wars.

The town was one of the first towns to commemorate the death of Nelson, and the monument in Exchange Flags, often named as the *Apotheosis of Admiral Nelson*, was unveiled in 1813. This was the first piece of public sculpture ever erected in Liverpool; it was designed by Matthew Cotes Wyatt (1777–1862) and sculpted by Richard Westmacott RA (1775–1856).

The entire sculpture is a powerful example of traditional English sentimentalism and hero worship, but also of self-confidence and boldness. Because of this it also epitomises the spirit of early nineteenth-century Liverpool.

There was one great war, though, that did not militarily involve Britain or Liverpool. Even so, it directly impacted on the economies of the country and the town. This was the American Civil War, which was fought between 1861 and 1865, with the issue of slavery and the Slave Trade at its core. Throughout this conflict Britain and Liverpool had to remain 'officially' neutral, but in fact were not at all.

Although Britain had abolished the Transatlantic Slave Trade in 1807, America had not. As a result, while Liverpool may have ceased trading directly in abducted human life, the town's wealth still depended to a large extent on commodities produced by slaves held captive on plantations in America's southern states and in the West Indies. Because of this Liverpool sought to influence the outcome of the vicious and bitter confrontation that America was waging with itself.

Above left: Then figure of Death trying, but failing, to keep a grip on Nelson's soul. (Courtesy of Discover Liverpool Library)

Above right: One of Nelson's 'captives', which surround the plinth of the monument. (Courtesy of Discover Liverpool Library)

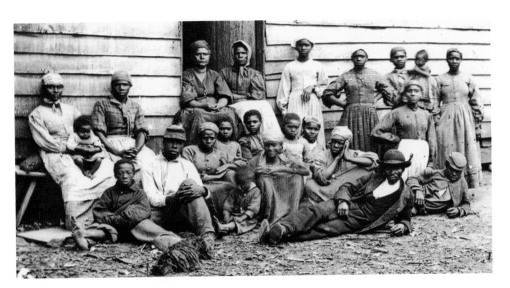

Slaves on a plantation in southern America.

7. Liverpool, Cotton, and Vessel 290

There had been a serious anti-slavery movement in the Northern states of American since around 1820, and following Britain's abolition of the trade this became stronger. In fact, the American president, Abraham Lincoln (1809–65), also wanted to abolish the slave trade in his country and emancipate (free) all existing slaves. He stated that he would make this a federal (governmental) matter and impose it on all states in the American Union.

The states in the south of the USA deeply resented what they regarded as government interference in their affairs and a threat to their sovereignty. The principal source of wealth for the people and administrations of these states came from the crops produced on plantations such as cotton and tobacco. These were worked by slaves, and their exploitation was woven into the economy and cultural fabric of southern American politics and society.

Because of the president's policy, in April 1861, seven states in the Deep South seceded from the Union. They now formed their own federation, which they named the Confederate States of America. They established a new government with overseas ambassadors, and adopted their own flag and currency.

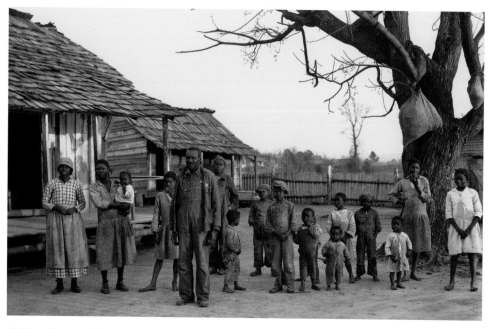

Children born on the plantations were born into slavery, and the American Civil War was fought to give them the freedom that was theirs and their parents' right.

American President Abraham Lincoln.
(Courtesy of Liverpool Athenaeum Library)

President Lincoln realised that his entire nation could break apart if the Confederacy was allowed to continue, but then four more states seceded. Lincoln now felt he had no alternative but to order a fleet of Union (Northern) states warships to blockade Confederate ports. The American Civil War had begun.

The blockade effectively stopped all maritime trade and warships from leaving or entering the Southern states. In particular this prevented the Confederacy from exporting cotton and tobacco to Europe and so damaged the economy of the rebels. This action also had a disastrous effect on trade with Great Britain, and especially on the Lancashire cotton industry. In fact, what became known as the 'Cotton Famine' devastated the mill towns across the county. The almost total unemployment, and resulting poverty and starvation, affected over 500,000 British working people.

Despite this hardship most British workers supported the anti-slavery movement. Not so the mill owners and cotton merchants, though, especially while so much profit was at stake. They also disregarded Queen Victoria's announcement of official British neutrality in the American war.

Liverpool may well have ended the triangular trade from its port, but the importation of cotton in particular remained essential to its own economy too. Who won the American Civil War, therefore, was vital to the interests of Liverpool as well as the rest of the country. This all dramatically increased support for the Confederacy among the leaders of the town.

The American president's official representative in Liverpool was the American consul, Thomas H. Dudley (1819–93), who masterminded a large network of spies from Liverpool. The American consulate offices at that time were in Paradise Street in the heart of the town. The building survives, still with a large carving of an American eagle mounted over the front entrance.

Above: The first flag of the Confederacy, raised in 1861. (Courtesy of Discover Liverpool Library)

Left: President Lincoln's consul in Liverpool, Thomas H Dudley, the Federal 'spymaster'. (Courtesy of Liverpool Athenaeum Library)

Dudley was infuriated that the Liverpool Chamber of Commerce, as well as many businesses and important traders, were actively encouraging the Confederacy. In fact, a fundraising Confederate Bazaar was held in St George's Hall in the town, with individual stalls named after the various southern states. This ran for five days and raised £20,000 (worth over £15 million in today's money).

Abraham Lincoln was fully aware of the very strong trading links the Confederacy had with Liverpool, and knew too that the rebels were seeking funds and supplies of arms from the town. The Confederacy was indeed very short of weapons so they sent agents to Liverpool where they were very well received. So much so, that in June 1861 an unofficial Confederate Embassy was opened in Rumford Place in the heart of Liverpool – the building survives today.

The Confederate ambassador was James Dunwoody Bulloch (1823–1901), and it was from Rumford Place that he arranged the largest single delivery of arms to the south, in October 1861. He also organised and oversaw the construction and purchase of specially built warships. These were designed to run the blockade and also to attack Union commercial shipping.

In all, forty-two blockade runners were built for the Confederate Navy in Liverpool and Birkenhead shipyards. Because of Britain's stated neutrality in the war, and to preserve secrecy, Bulloch signed the contracts in his own name as private purchases. The most notorious of these 'secret' ships was known simply as *Vessel Number 290,* and it was built in the Birkenhead shipyard of John Laird & Sons.

Work began on this on 14 May 1862, and construction continued at a very fast pace so that Laird's could get it out of the shipyard before the highly risky and illegal deal was discovered. The purpose and ultimate destination of the ship was kept a closely guarded secret from the shipyard workers and Laird staff. Nevertheless, of course, John Laird and the British government were fully aware of what was going on and helped keep the project clandestine.

The Confederate 'Ambassador' to Liverpool, and supplier of weapons and warships James Dunwoody Bulloch. (Courtesy of Liverpool Athenaeum Library)

The Laird shipyard in Birkenhead at the time of the American Civil War. (Courtesy of Liverpool Athenaeum Library)

Vessel 290 was a 1,040-ton, 300-hp wooden screw steamer. It measured 210 feet (64 metres) in length and had a beam of 32 feet (9.75 metres). It cost the Confederacy £47,500 (more than £2 million in today's money). She was constructed with reinforced decks for cannon emplacements and with gunpowder magazines below water level. Although, to help keep the ship's secret and Britain's legal neutrality, it was not equipped with arms in the shipyard.

The mystery ship was finally launched on 15 May 1862, using a cover name of *Enrica*. Even so, Lincoln's consul and 'master spy' Thomas H. Dudley discovered what was going on. In fact, it was perfectly obvious that this was a warship because holes had been cut in its sides for guns, even though there were no guns on board.

On 22 July the United States began making official complaints to the British government. They insisted that the work on the ship be stopped but the British stalled. While this diplomatic wrangling was going on, Laird's continued to complete the fitting out of *Enrica*. For around two weeks in early July she lay in the Great Float dock at Wallasey and the work was almost completed.

However, Laird's and Bulloch heard that their plan had been discovered so *Enrica* sailed from Liverpool on 29 July 1862. Because this was earlier than had been planned, and because she may have been prevented from leaving, it was made public that a final sea trial was to take place on this day. To give plausibility to this story a party of VIP guests was invited on board. This included John Laird and members of his family.

Very few people aboard had any idea that the ship would not be coming back to Liverpool. The blissfully unaware passengers simply enjoyed a day's sailing around Liverpool Bay. They were then all transferred to a tugboat that had been following at a

The mystery ship *Enrica* at sea, soon to be revealed as CSS *Alabama*.

discreet distance and were returned home. *Enrica*, meanwhile, left the Mersey for good and made for Moelfre Bay in Anglesey, North Wales, with a crew made up principally of Liverpool volunteer sailors.

She was only in Wales for a couple of days when, on 31 July, a warning was received that the vessel was to be seized that day. She sailed immediately and made for Terceira in the Azores, where the ship arrived on 13 August. A few days later *Enrica* was joined by the London registered *Agrippina* carrying guns, coal, food, and ship's supplies. Soon afterwards another ship, *Bahama*, arrived. On board was Captain Raphael Semmes (1809–77) of the Confederate Navy. He had already spent time in Liverpool staying with James Dunwoody at his home in the north Liverpool district of Waterloo. With Semmes were fourteen, predominantly American, officers. These now joined the 120 Liverpool volunteers on board and the new ship's compliment was complete.

The Birkenhead-built warship was now finally fitted with her guns and munitions and made ready to sail. On 24 August 1862 a ceremony was held at sea, the Confederate flag was raised on board, and *Enrica* was renamed *Alabama*. The ship's motto, 'Aide-toi et Dieu t'aidera' ('God helps those who help themselves'), was then engraved in the bronze of the ship's double wheel, and *Alabama* set sail on active service for the Confederate rebels.

For the next two years *Alabama* became the scourge of Union America's warships and merchantmen, and she became the most feared and destructive raider in maritime history. On 5 September *Alabama* made her first capture. Within eleven days of this she went on to capture and destroy vessels worth more than she had cost to build.

Over the next twenty-two months she sank or captured and then burned twenty-five sailing ships, four brigantines, six schooners, and seventeen barques, complete with their cargoes. This was a loss to the Union of property worth over $5.2 million. In fact, so great was the damage caused by *Alabama* and other Confederate raiders that President Lincoln threatened to hang their crews for piracy if they were captured.

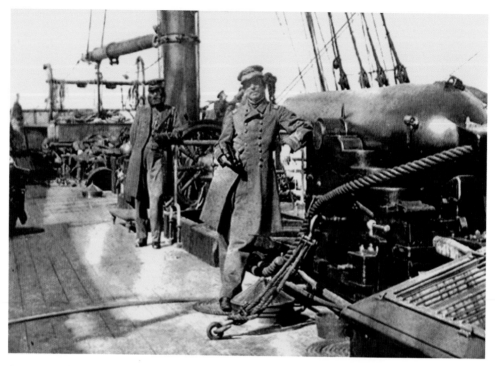

Captain Raphael Semmes and First Lieutenant John Kell aboard CSS *Alabama*.

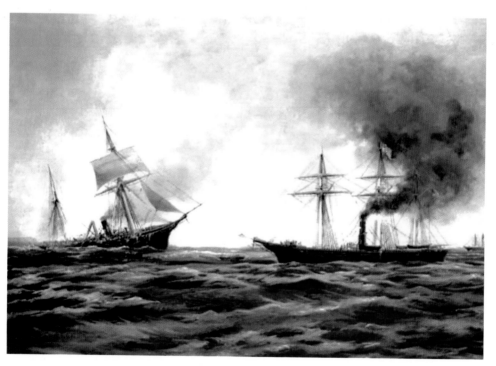

Kearsarge sinks Alabama on 11 June 1864.

On 11 June 1864, *Alabama* was resupplying and undergoing repairs at Cherbourg in France, when the Union warship USS *Kearsarge* appeared off the coast. On 19 June *Alabama* sailed out to confront her, but *Kearsarge* remained around 500 yards away. After what was described as a 'spectacular battle' the American gunners fired so effectively at *Alabama* that within an hour the raider began to sink and the crew struck the ship's flag. An English yacht sailing nearby rescued Captain Semmes and many of his crew to prevent them being captured by the Americans.

With the end of the American Civil War the United States claimed compensation from Britain for the damage done to its shipping, by *Alabama* and other Mersey-built raiders, including *El Tousson, Banshee, El Monasir,* and *Florida.* The claim went to arbitration and the UK government lost, being forced to pay £3.23 million to the USA. This was the equivalent to £150 billion in today's money.

Confederate 'ambassador' to Liverpool James Bulloch stayed in Liverpool after the war, where he became a successful cotton trader. He died in 1901 and lies buried in Liverpool's Toxteth Cemetery. His gravestone says, 'American by birth Englishman by choice'. Bulloch's nephew, Theodore 'Teddie' Roosevelt (1858–1919), visited him in Liverpool and went on to become president of America.

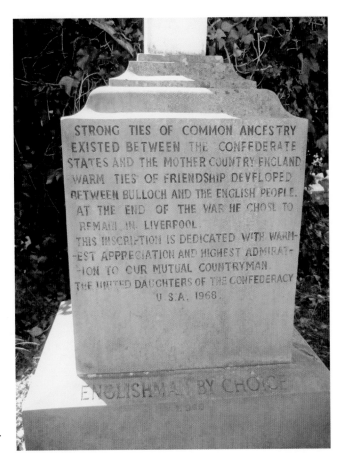

James Bulloch's grave in
Toxteth cemetery in Liverpool.
(Courtesy of Tombstoner)

James's half-brother, Irvine Stephen Bulloch, CSN (1842–98), also lies buried in the same cemetery. He was the youngest officer on board the CSS *Alabama*, and it was he who fired the ship's final shot before it was sunk. James's sister, Martha (1835–84), was the mother of Theodore Roosevelt and the grandmother of Eleanor Roosevelt (1884–1962). Eleanor would visit Liverpool during the Second World War as the representative of her husband, President Franklin D. Roosevelt (1882–1945).

However, the story of Liverpool's connection with the American Civil War and its politics does not end here. In fact, there is a significant footnote.

On 3 August 1865, Commander James Waddell (1824–86) of the confederate raider CSS *Shenandoah* received information that the Civil War had ended. Not wanting to surrender to the Union for fear of imprisonment and execution, he chose to sail 17,000 miles to 'Confederate-friendly' Liverpool. On 6 November 1865, he anchored his ship in the middle of the Mersey and then lowered his Confederate flag. He next handed over *Shenandoah* to Captain Poynter of the Royal Naval vessel HMS *Donegal*, which was also anchored mid-river.

Commander Waddell then made his way to Liverpool Town Hall, where he walked boldly through the main entrance. In his hand he held a letter addressed to Liverpool's lord mayor, formally surrendering his vessel to the British government. This was the last official act of the American Civil War, which ended not in America but in Liverpool.

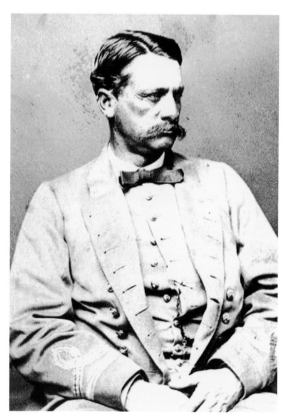

Commander James Waddell, who surrendered his ship, and then the Confederacy, in Liverpool.

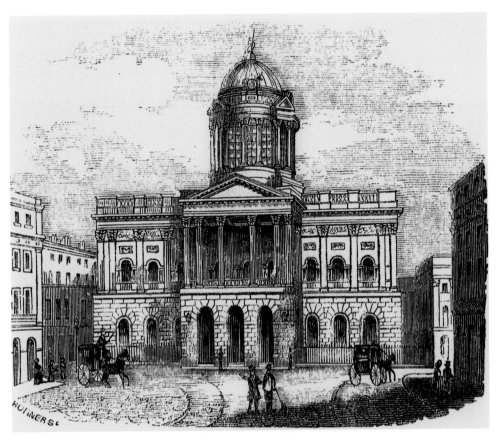

Sketch of the main entrance of Liverpool Town Hall, as it would have looked to James Waddell. (Courtesy of Discover Liverpool Library)

As the town's links with Confederate America show, Liverpool's military heritage is a mixture of chance, victimhood, triumph, opportunism, profit and loss, spectator, and participant. While it continued to play its part in Europe's and the world's great conflicts the economy and population of the town boomed. By the end of the nineteenth century Liverpool was one of Europe's largest and most successful conurbations. So much so that, in 1880, it ceased to be merely a town and was awarded city status.

Even so, war was never far away, but now Liverpool people found themselves more actively involved in the fighting than ever before – on land and at sea. This began with the Boer War, which was fought between Britain and the Orange Free State (now South Africa) from 1899 to 1902.

But then, in 1914, the most horrific international war the world had yet experienced broke out, with so many more Liverpudlians serving in the armed forces than in any previous conflict.

8. Kings, Pals, and Patriots

On 28 June 1914, at Sarajevo in Bosnia, the heir to the throne of the Austro-Hungarian Empire, Archduke Franz Ferdinand (b. 1863) and his wife Sophie, Duchess of Hohenberg (b. 1868), were assassinated. This precipitated what was to be initially described in its immediate aftermath as the 'War to End All Wars'. Tragically, however, this would eventually enter history as the First World War.

For generations Liverpool had provided young men as soldiers for the British Army, so much so that the renowned King's Regiment (Liverpool), formed in 1685, had always been made up mainly of men from the town. This tradition continued when Britain declared war on Germany on 4 August 1914, just five weeks after the shooting of the archduke.

The outbreak of the war generated a period of romantic patriotism and imperialist jingoism right across Britain. Posters appeared everywhere of Lord Kitchener (1850–1916), who was then Secretary of State for War. He was shown, behind his great moustache, pointing his finger and stating 'Britain Needs You'. This prompted the young men of Britain to see themselves as the nation's saviours and heroes.

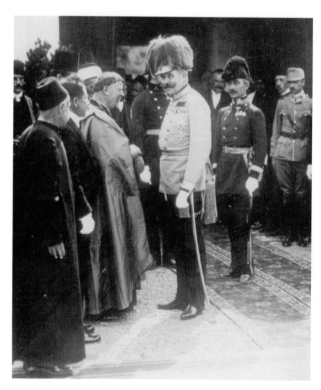

Austrian Archduke Franz Ferdinand in Sarajevo on the day of his assassination. (Courtesy of Liverpool Athenaeum Library)

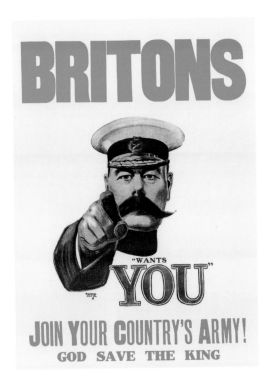

Lord Kitchener demanding a response on one of the most famous propaganda posters of the war. (Courtesy of Discover Liverpool Library)

This was a time too when old soldiers from previous imperial wars were also urging young men, especially in Liverpool, to 'get out there and see some action' and 'if you don't go now you'll miss it. It'll all be over by Christmas!' Girlfriends and fiancées also told their young men that they should go to war and 'do their bit for King and Country'.

These youngsters, for such they were, could not even escape the propaganda in the music halls because their favourite female singers were regaling them with rousing verses from a song entitled 'Your King and Country Want You'.

What was a young man to do? If he did not sign up to fight then he might very well receive a white feather, sent to him anonymously in the post and marking him out as a coward. In fact, though, most young men actually did want to go, especially in Liverpool. This was because they saw this as the honourable and right thing to do. Apart from this, and in the naïvety of the time, they thought that the war was bound to be a 'glorious adventure'.

So, go they did to 'answer their Country's call' in their hundreds of thousands, and no more so than from Liverpool. But an adventure was the last thing this war was going to be, because of the complete failure on the part of the military and political leadership to recognise the implications of fighting a modern mechanised war. No one had any conception of the unprecedented horrors that this would unleash on an unsuspecting Europe, and beyond.

Liverpool's young men were sent to fight in the muddy swamps that were the trenches of France and Belgium. Not because they were fools, but because they believed in themselves and in Britain, and in the rightness of the patriotic cause. With that sense of community and tribalism that is so particular to Liverpool they also went as pals.

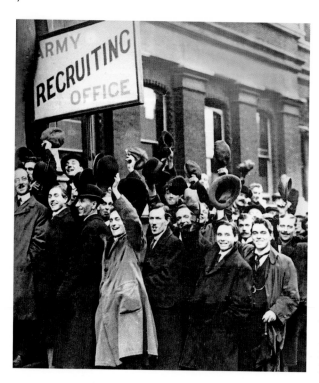

The spirit of 'doing their bit for Britain' really gripped these young men. (Courtesy of Liverpool City Records Office)

It was Edward George Villiers Stanley (1865–1948), 17th Earl of Derby, whose idea it was to recruit groups of young men who were already comrades and friends to form a new fighting regiment. Also serving as Secretary of State for War, from 1916 to 1918, Lord Derby ordered that an advert be placed in Liverpool's newspapers on 27 August 1914. This suggested that men wishing to join 'a battalion of comrades, to serve their country together' should report to the headquarters of 5th Battalion the King's Regiment Liverpool.

The response overwhelmed the capacity of the recruiting hall and extra rooms had to be opened to deal with the numbers of men eager to enlist; already there were enough to form two battalions. The volunteers were then all told to come to St George's Hall on 31 August, where they would be officially enlisted. Here, Lord Derby took the opportunity to deliver a rousing, patriotic speech to an audience of 1,050 new recruits, using the phrase 'Liverpool Pals' for the first time.

'This should be a Battalion of Pals,' the wealthy aristocrat told the enthusiastic but enthralled crowd. 'A battalion in which friends from the same office will fight shoulder to shoulder for the honour of Britain and the credit of Liverpool.' He went on:

I don't attempt to minimise to you the hardships you will suffer, the risks you will run. I don't ask you to uphold Liverpool's honour; it would be an insult to think that you could do anything but that. But I do thank you from the bottom of my heart for coming here tonight, and showing what is the spirit of Liverpool – a spirit that ought to spread through every city and every town in the kingdom.

Edward Villiers Stanley, the 17th Earl of Derby, was the inspiration for the very many battalions of 'Pals' who marched off to war. (Courtesy of Discover Liverpool Library)

In the following weeks and months men and boys from all over Liverpool continued to sign up. They did so in small groups, as 'mates'; and as complete neighbourhood football teams; as bands of apprentices or workers from single factories, offices, and shipping lines; as neighbours from single streets; as fellow worshippers in churches and synagogues; and as gangs of lads from corner pubs.

The reaction to the emotional recruitment campaigns was phenomenal, so much so that the volunteers eventually made up four battalions of the King's Regiment Liverpool – the 17th, 18th, 19th and 20th – with each battalion comprising an average of 1,400 men. The King's represented the City of Liverpool and was one of only four regiments affiliated to a city in the British Army.

Alongside the battalions of the King's Regiment there were also the Liverpool Scottish and the Liverpool Irish regiments. These had originally been established as Reserve and then later as Territorial infantry troops. They were made up of volunteers from the city whose ancestry was from those particular parts of the British Isles. The Scots, the Irish, and the Welsh always have – and still –made up sizeable communities within the larger community of Liverpudlians. They were all to play their part in the First World War with courage, honour, and typically 'Scouse' indefatigability!

As well as the city of Liverpool sending volunteers to fight, equally significant was the Wirral Battalion of the Cheshire Regiment. Young men from all over the towns and villages of the Peninsula also left their homes and loved ones to fight overseas. The largest contingent of these recruits joined from Port Sunlight, mainly from the Lever Brother's Works. Indeed, the greatest number of volunteers obtained from any works in the country came from this Wirral soap factory.

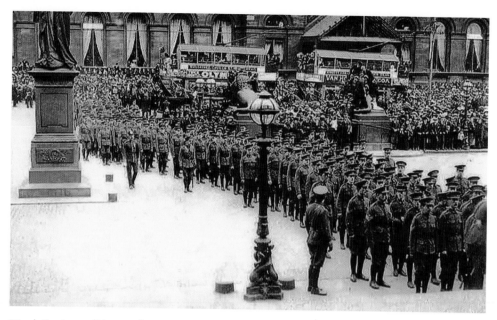

King's Regiment (Liverpool) recruits muster at St George's Hall on Liverpool's Lime Street in 1914. (Courtesy of Liverpool Athenaeum Library)

However, the war was essentially being fought as a protracted game of stalemate between the combatants. On opposing sides of a broad stretch of open ground that formed the battlefield, known as no man's land, each army faced the other from lines of deep trenches. These often stretched for miles and were occupied not just as defensive positions but as the troops' homes. In turn, and as a prelude to a ground-based attack by their soldiers, each side continuously bombarded the other, often for hours, using heavy artillery that was positioned behind their own lines.

Hoping that this assault would have weakened and decimated their enemy they then prepared to 'go over the top' and climb out of their trenches and make their way across no man's land, while under very heavy fire from the enemy trenches.

For the most part, though, the trenches provided excellent protective cover, thus rendering the artillery assaults largely redundant. This meant that advancing and exposed troops would face a barrage of shell and machine gunfire that would mow them down, often in huge numbers. No man's land separated the opposing lines of trenches and could be anything from fifteen to several hundred yards wide. This bleak terrain rapidly became a quagmire of mud, blood, and bodies in a tortured landscape of shell holes and hellish destruction.

The trenches too would become either rivers of mud and filth during the rains, ice-cold channels of frozen earth in the winters, or sweltering concentrations of energy-sapping heat in the summer. For three and a half years this was how the war was waged, with territory being captured or lost often only in measurements of yards rather than miles.

In late 1915, the Liverpool Pals battalions had been sent to training camps in France, near the River Somme, ready for what was being called 'The Big Push'. This would take

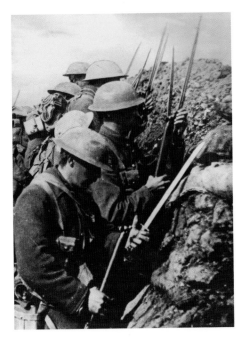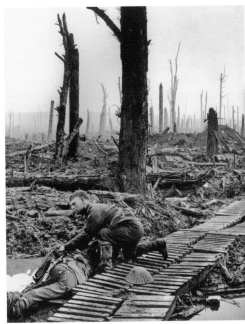

Above left: Preparing to go 'Over The Top'. (Courtesy of Liverpool Athenaeum Library)

Above right: The realities of no man's land. (Courtesy of Liverpool Athenaeum Library)

place in the summer of the following year. By the morning of 1 July 1916, the Liverpool Pals were on the front line. Then the order came and these young Liverpudlians charged across no man's land. Immediately, almost 200 of them were killed outright and over 300 were wounded, taken prisoner, or eventually declared missing. In total, over 13,000 King's Regiment soldiers died. This war being what it was, far too many of those who were killed never had their own graves. These soldiers are remembered, though, on the Memorial to the Missing of the Somme at Thiepval in France.

Of the four original Pals battalions who sailed to France in November 1915, 20 per cent would be dead by the end of the war. But, if the figures of the wounded are added to this, then the actual number of casualties is nearer 75 per cent. Those football teams, church congregations, factories, shops, streets, and pub bar rooms would be decimated and never the same again. Nevertheless, these young men died and suffered as proud Liverpudlians, Lancastrians, and Cestrians, determined to do their duty as they saw it.

Writing home to his family on the eve of his regiment's departure for France, and destined to be killed in his first battle, one young soldier, Private W. B. Owens, wrote:

Well we're away at last and 'tho no one feels that it's a solemn occasion to be in England for perhaps the last time, I think that the predominant feeling in every chap's heart – in mine at any rate – is one of pride and great content at being chosen to fight and endure for our dear ones and the old country.

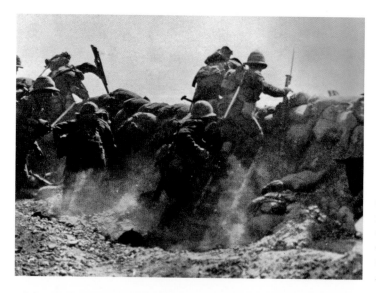

Going 'Over the Top' into battle across the deadly devastation of 'No Man's Land'. (Courtesy of Liverpool Athenaeum Library)

Just a few of the very young, naïve recruits who signed up in 1915. (Courtesy of Liverpool City Records Office)

Boys as young as fourteen joined up to go overseas, lying about their ages often with the collusion and encouragement of family, friends, and of the recruiting sergeants. Initially flushed with pride, so many of their lives would end brutally as they fought and bled in the mud. Thousands more were gassed, mutilated, wounded, and psychologically damaged, but at least they would eventually make it home alive.

However, so many of the Liverpool Pals, the Liverpool Scottish and the Liverpool Irish, and the Wirral Battalion did not. They were among those local soldiers who were massacred on the European battlefronts of that 'foreign field that is now, forever England'.

During the First World War, 5,397,000 men had been mobilised from across Britain. Of these, 703,000 were killed and 1,663,000 wounded. This is a total of 2,367,000 war casualties, or 44 per cent of the serving men.

One of the heroes of the conflict, though, was Noel Godfrey Chavasse (1884–1917) from Liverpool, the son of the then bishop of the city. Noel, who was a medical officer attached to the Liverpool Scottish, received the Victoria Cross twice for saving the lives of his comrades on the battlefield. Tragically, Noel too was killed, so his medals were awarded posthumously. He was the sole recipient of two VCs during the First World War.

In total, nine Victoria Crosses were awarded to men of the King's Regiment – the first in 1900 and the last in 1918. This last honour was awarded to Private Jack Counter of the 1st King's. On 16 April 1918, he volunteered as a messenger, despite having witnessed five preceding runners killed – happily, Jack survived. A sculptured bronze tribute to Noel Chavasse and Liverpool's fifteen other VC medalists, by local artist Tom Murphy, was unveiled in 2011 in the city's Abercromby Square.

After centuries of fighting in Britain's wars the King's Regiment (Liverpool) saw active service in the Boer War (1899–1902) and both world wars. In the First World War the regiment contributed dozens of battalions to the Western Front, Salonika, and the north-west frontier. In the Second World War (1939–45), the 5th and 8th (Irish) battalions

Noel Godfrey Chavasse, who twice received the Victoria Cross, and who died of his wounds. (Courtesy of Liverpool Athenaeum Library)

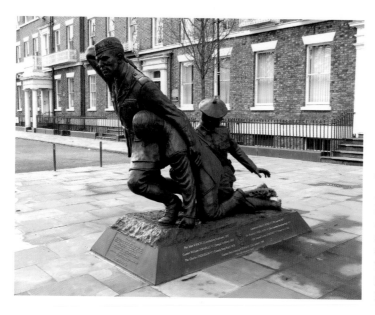

The memorial to the sixteen men from Liverpool whose courage and sacrifice earned them Victoria Cross medals for bravery. (Courtesy of Discover Liverpool Library)

landed during the D-Day landings; the 1st and 13th fought as Chindits in the Burma Campaign; and the 2nd Battalion served in Italy and Greece. The King's later fought in the Korean War (1950–53), earning the regiment's last battle honour.

After 273 years of continuous existence, the regiment was amalgamated with the Manchester Regiment in 1958, to form the King's Regiment (Liverpool and Manchester). This was later amalgamated with the King's Own Royal Border Regiment and the Queen's Lancashire Regiment to form the present Duke of Lancaster's Regiment (King's, Lancashire and Border).

A stunning large memorial group was sculpted by William Goscombe John (1869–1952) to commemorate the regiment. This was erected in St John's Gardens, Liverpool, where it still stands. It was unveiled on 9 September 1905, and its most striking figure is a representation of a young uniformed drummer boy. Positioned at the rear of the monument, he is shown doing his duty and beating out the advance. However, his face betrays the terror he is experiencing as he goes into battle, perhaps for the first time; we hope it does not also represent his last.

The end of the First World War began quite suddenly, for a combination of reasons, in the summer of 1918. These were the entry of the Americans into the conflict, in April 1917; the more strategic use by the Allies of tanks supporting ground assaults; and the use of aircraft for air cover, filming of enemy positions, and for guiding artillery strikes. Coupled with a German army that was by now completely exhausted, under-equipped, and demoralised, the end was inevitable.

There was no ultimate victory in what had also been dubbed the 'Great War'. It ended with an armistice, which was signed at 5 a.m. on 11 November 1918. At 11 a.m. on that day in London, Big Ben struck for the first time in four years. In Liverpool, church bells rang out around the city, which could be justly proud of the service given and the high price paid by so many of its young men.

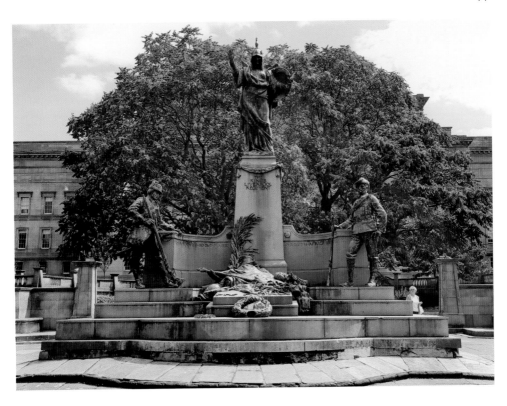

Above: The imposing monument remembering and celebrating the men of the King's Regiment (Liverpool) over centuries of service. (Courtesy of Discover Liverpool Library)

Right: The drummer boy on the regimental memorial. (Courtesy of Discover Liverpool Library)

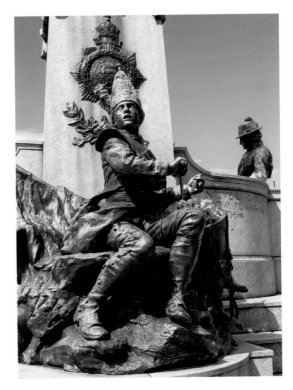

9. Convoys and Blitzkrieg

As the second decade of the twentieth century began there was a period of economic growth, of radical social change, and a broadening of accessible democracy right across Britain. Then in 1929 the collapse of the American stock market was one of the catalysts for a global economic failure that became known as the 'Great Depression'. Europe and Britain suffered badly, especially in heavily populated and industrialised conurbations such as Liverpool. Mass unemployment, poverty, and disease took their toll on the city, but by the mid-1930s Liverpool began to emerge from this as the international economy strengthened once more.

The city, and its port, was soon able to recover its position as the hub of global maritime trade, as a world-class city, and as the 'crossroads of the world'. Indeed, the highest population ever reached in Liverpool was in 1937, when 867,000 people were resident within the city boundaries. This was a time when Liverpool could also genuinely celebrate its place in the modern twentieth-century world as a 'new Rome' and a 'seat of empire'.

This was also a peak time for the great shipping lines of the world. These were not only using the port regularly, but many had their headquarters in Liverpool. However, just as the global economy was strengthening, and as optimism and hope once more began to rise, so too did the power of Germany, under the Nazi leadership of Adolf Hitler (1889–1945). Soon, this latest German dictator would enshroud the world in the black shadow of war. The people of Liverpool would again answer the call to fight against an enemy that was determined to dominate and subjugate the globe.

This time, though, the entire population of the city played their part – men and women. They did so in the Army once more; willingly in the Royal and Merchant navies; with the Royal Air Force; and on the docks, in the factories, and on the farms. Now, and just as previous warmongers had discovered, Hitler too would learn the hard way that Liverpudlians aggressively resist domination in any form.

The importance of Liverpool's role throughout the Second World War cannot be underestimated. During this next, great conflict, after the fall of France in 1940 and before America came into the war in December 1941, Britain stood virtually alone against the Nazi juggernaut that had rolled out across Europe. Liverpool was vital to the nation's survival, because it was to the port that the convoys of ships brought vital supplies of food, fuel, medicines, raw materials, and munitions. These were then transported to the rest of beleaguered Britain by rail, road, canal, and air.

Protected by an escort force of warships of the Royal Navy and Britain's allies, especially Canada, these lines of up to sixty merchant vessels at a time sailed into Liverpool Bay. They came from America, Canada, and around the British Empire, as well as, in due course, from Soviet Russia. These supplies were keeping Britain alive and fighting.

The German Chancellor, Adolph Hitler, practising his techniques for dominating an audience Liverpool Athenaeum Library.

Hitler was perfectly aware of this, and of the port's strategic position, and so he launched a relentless campaign of warship and submarine U-boat attacks on the convoys. This assault was under the command of Grand Admiral Karl Dönitz (1891–1980).

It was not just supplies coming into Liverpool that had to be protected, because it was also through the city's docks that no fewer than 1,747,505 Allied Service Personnel passed. Indeed, during the war 4,648 special trains arrived from across Britain at the Riverside station (which no longer exists) standing alongside Princes Dock on the Liverpool waterfront.

From here these troops left Liverpool on ships bound for theatres of war around the world. In fact, on one particular tide there were twelve ships queuing up in the River Mersey, waiting to pick up soldiers who had disembarked from America. These men then travelled by train from Liverpool to the south of England. On 6 June 1944, they joined the Allied assault on Europe in what became known as the D-Day landings in France.

The Royal Navy fought a determined resistance against German attacks on Allied convoys that history calls the Battle of the Atlantic. This was the longest-running -campaign of the war because it lasted for the entire duration of the conflict. The first attack on a British ship had been the sinking of the passenger liner SS *Athenia*, which had been sailing from Liverpool to Canada. The unarmed civilian vessel was torpedoed on 3 September 1939, only eight and a half hours after war had been declared. A total of 117 passengers and crew lost their lives.

The final attacks of the Battle of the Atlantic resulted in the sinking of the British freighter, *Avondale Park*; of the Allied minesweeper, *NYMS 382*; and of the Norwegian merchant steamer, *Sneland*. These enemy actions took place in separate incidents, only hours before the German surrender on 2 May 1945. Nevertheless, during the war around 1,500 convoys of between twelve and sixty ships each, around 76,000 vessels in total, successfully thwarted the German (and later Italian) submarines and entered Liverpool mainly through Herculaneum Dock.

A convoy of life-saving merchant ships, escorted by Royal Naval vessels, braves the North Atlantic Ocean to enter the docks at Liverpool. (Courtesy of the Western Approaches Museum Liverpool)

This crucially strategic naval campaign was commanded by Admiral Sir Max Horton (1883–1951). He directed his 'Scarecrow Patrols' of de Havilland Tiger Moth, single-propeller bi-planes, to spot enemy U-boats in the North Atlantic Ocean and radio back their positions. This information was then passed to the Royal Navy vessels protecting the convoys. These were then guided into Liverpool Bay and the Mersey by an escort force of warships, set to defend a rectangular area of the North Atlantic along the coast of the British Isles, known as the Western Approaches.

These battle-ready escorts were under the command of the highly respected Captain Frederick John 'Johnnie' Walker (1896–1944), whose leadership and strategic skills were renowned. He had been about to retire at the outbreak of the war but agreed to take command of the 36th Escort Group, based in Liverpool, and he was very effective. Mentioned in dispatches three times during his career, Captain Walker was awarded the Distinguished Service Order on 6 January 1942. This was after his group sank five Nazi U-boats while escorting a convoy of over thirty vessels. In command of the sloop HMS *Stork* Walker fought and won many battles, and was awarded a Bar to his DSO on 30 July 1942.

In 1943, Captain Walker took command of the sloop HMS *Starling* and of the 2nd Support Group. This was tasked with seeking out, attacking and sinking enemy submarines, and that year he succeeded in sinking six enemy vessels. His actions continued with equal success and, in January 1944 alone, he sank a further five U-boats. Ships under the command of Captain Walker destroyed more enemy submarines than those of any other Allied naval commander. In 1944, on 22 February, he was awarded a 2nd Bar to his DSO, and later on 13 June Captain Walker received his 3rd Bar.

The highly respected, and very successful, Captain Johnnie Walker aboard his ship, *Starling*, in 1944. (Courtesy of the Western Approaches Museum Liverpool)

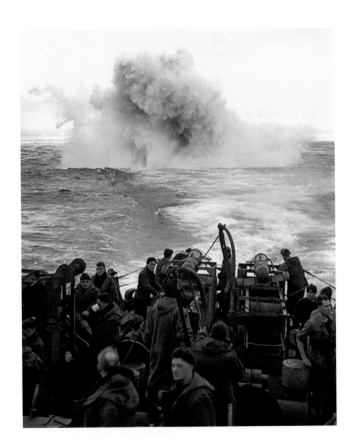

HMS *Starling* drops a depth-charge on an enemy U-Boat in 1944. (Courtesy of the Western Approaches Museum Liverpool)

The map room where operations were planned and monitored, deep underground in 'The Fortress'. (Courtesy of the Western Approaches Museum Liverpool)

The defense planning for the Western Approaches and the direction of the Battle of the Atlantic all took place in 50,000 square feet of gas-proof and bomb-proof bunkers in the basement of Derby House, in Exchange Flags, behind Liverpool Town Hall. When the Second World War was declared this underground operational headquarters for Atlantic Defence and Conflict was being constructed. Fully completed in 1941, and known as 'The Fortress', it was from here that a continuous and dedicated maritime defence and attack was directed against these enemy assaults on Allied shipping.

Sadly, Frederick 'Johnnie' Walker suffered a brain haemorrhage in the summer of 1944 and died two days later on 9 July in the Naval Hospital at Seaforth in north Liverpool. He was so respected by his men and fellow officers, and by the people of Merseyside, that over 1,000 mourners attended his funeral. This was held with full naval honours in Liverpool Anglican Cathedral following an emotional procession through crowded streets. 'Johnnie' Walker CB, DSO and three Bars, RN, was buried at sea, and a life-size statue of him by renowned local sculptor Tom Murphy stands at the Liverpool Pier Head overlooking the river.

During the Battle of the Atlantic, and despite achieving ultimate victory, the Allied losses were astronomical. The worst years were 1941 and 1942 when, respectively, 1,300 and 1,661 ships were sunk. In total, over 12.8 million tons of Allied and neutral shipping was destroyed, but the loss of life was the real catastrophe. Royal Naval losses totalled 73,600, with a further 30,000 sailors being killed from the Merchant Service. An additional 6,000 men from Coastal Command and 29,000 from the Anti-German-U-boat Flotilla also died. Memorials to these gallant sailors can also be found at the Pier Head, together with those dedicated to the Merchant Navy, to Norwegian Seamen, to 'All those Lost at Sea', and to Belgian Merchant Seamen, among others.

The entrance to the underground war rooms today, open to the public as the Western Approaches Museum. (Courtesy of the Western Approaches Museum Liverpool)

In 1998, the road that passes in front of the Three Graces, at the Pier Head, was renamed as Canada Boulevard. This is an avenue of maple trees (the national tree of Canada), which was first planted in 1995 by the Canadian government. The Canadian Navy provided outstanding military support to the British Navy in their defence of the convoys, and these trees form 'a living memorial to Canadians' who had been killed during the Battle of the Atlantic.

The British wartime prime minister, Sir Winston Churchill (1874–1965), wrote in his history of the Second World War that 'The only thing that ever really frightened me during the War was the U-Boat peril.' It is certainly true that without the Liverpool-led victory during the Battle of the Atlantic, Britain would probably have been defeated by the Nazis.

The underground headquarters of the Western Approaches Command 'Fortress' is open to the public as a museum and is set out exactly as it would have looked during the war. Visitors wander through authentically furnished and equipped bunkers, map and radio rooms, corridors and offices. They can imagine for themselves what it must have been like for the men and women stationed here during the defence of Liverpool, Britain, and the North Atlantic.

Liverpool was not only a command centre, but also a communications and supply hub for the rest of Britain. The interconnected dock system itself was directly linked to a major road, rail, and canal network that was vital to the country's survival and freedom. This was another major reason why Adolf Hitler was absolutely determined to destroy the strategically vital port and city. The Nazi dictator specifically ordered the commander of the German Luftwaffe (air force), Reichmarshall Hermann Goering (1893–1946),

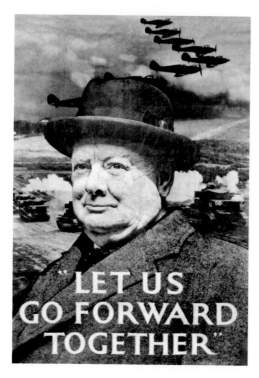

Winston Churchill propaganda poster in the Western Approaches Museum. (Courtesy of the Western Approaches Museum Liverpool)

to 'bomb Liverpool into oblivion'. Now, those ordinary people left at home while their loved ones were away at war found that war came to them. They too became direct targets of the Germans.

The children of Merseyside too shared in the challenges and suffering that modern warfare inevitably creates. While many of their parents decided that their young sons and daughters should remain at home with their families, many more decided that, though extremely painful, it would be safer to send them away for the duration of the war. In fact, government preparations had been in hand since November 1938 to systematically evacuate children from areas in the country at high risk from German bombing. This included Liverpool, Birkenhead, and Wallasey.

From 1 to 5 September 1939, thousands of children were evacuated from Liverpool, mostly to the less vulnerable area of Wales. However, many Liverpool children were also evacuated to other parts of rural Britain, and for many of these urban children their new environments were like alien worlds. Their sudden transplantation into new families and communities was frequently as radical a culture shock for their hosts as it was for the children.

Once the Germans began bombing Merseyside in earnest in August 1940, thousands more children were also sent away on ships to the safe shores of Canada and America. Many of these sailed from Liverpool aboard great ocean-going liners that often carried up to 2,000 of them at a time. All these transports were under constant threat of attack from the Nazi U-boats and they all needed protection by Royal Navy ships. Tragically, though, not every passenger ship reached its destination safely.

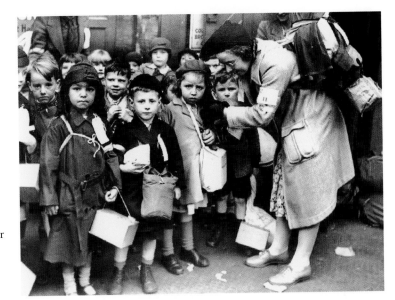

A group of very anxious, and very young, evacuee children prepare to leave their Liverpool homes for the safety of rural Wales. (Courtesy of Liverpool City Records Office)

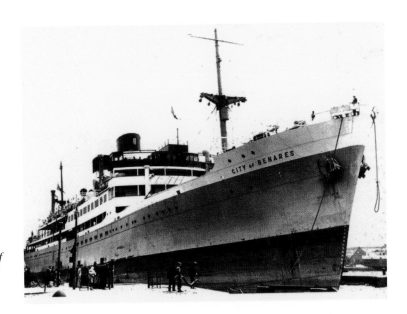

The ill-fated *City of Benares*. (Courtesy of Liverpool City Records Office)

On 13 September 1940, the liner *City of Benares* set sail from Liverpool in a convoy of nineteen ships bound for Canada. She had 406 passengers and crew on board including around ninety children. The ship was initially escorted by a naval destroyer on the dangerous part of the voyage but after four days the escort left them. Without warning the German submarine U-48 torpedoed the *City of Benares* on 17 September and 262 people on board lost their lives with only thirteen children surviving.

Throughout Europe, one of Hitler's most devastating and effective modes of warfare was his blanket bombing of industrial centres, docks, railways, warehouses, factories and

shipyards, and of the areas of civilian population around them. Not concerned about how many innocent men, women, and children he slaughtered, his 'Blitzkrieg' or 'Lightning War' bombings of towns and cities across the Continent laid waste to many heavily populated areas. Britain suffered very badly too under these callous aerial bombardments, but Liverpool and Merseyside most of all.

The first German bombs landed on Merseyside on 9 August 1940 at Prenton in Birkenhead, followed by intermittent air raids of varying intensity over the coming months. Most of these were targeted on the full length of the working Mersey waterfront, yet despite this those docks that remained undamaged were as busy as ever. Over the weekend of 26 April 1941 they handled over 136,000 tons of food and animal feed, and around 45,000 tons of other cargo.

Just five days later one of the most violent aerial assaults on any British city, the real Blitz, was launched against Liverpool – every night from 1 to 8 May 1941. This was the worst week of continual, heavy bombing raids ever, on any part of the country. It was an all-or-nothing attempt by the Germans to wreck the port from which the Western Approaches were being defended. In that single week 1,453 people were killed and more than 1,000 seriously injured.

After this, the Nazis continued to bomb Liverpool almost every night during the remainder of May, and through the first two weeks of June. Altogether, there were seventy-nine separate air raids during the Blitz, leaving the centre of the city lying

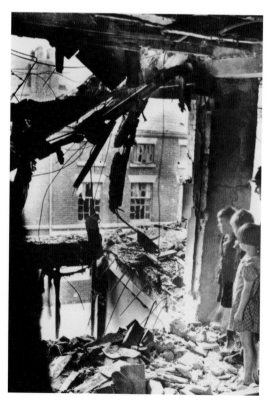

This was their home. (Liverpool Athenaeum Library)

in waste. Also, many of the Mersey docks were heavily damaged, notably the Wapping and Albert docks. Also, Huskisson No. 2 Branch Dock was obliterated when, on 3 May 1941, the vessel SS *Malakand* took a direct hit from a high-explosive bomb and blew up.

The ship was carrying 1,000 tons of ammunition in her holds and when she was hit great chunks and sheets of shrapnel were blasted into the air. Some of these were propelled for a distance of over 2½ miles, and one of *Malakand's* 4-ton anchors was thrown for a distance of over 100 yards. The entire dock area itself was devastated, together with adjacent warehouses and dock sheds, as was the Huskisson Dock station of the 'Overhead Railway'.

One dock worker was blown off his feet by the explosion and, as he was about to get up off the ground, one of the ship's great metal plates blew on top of him. To his amazement it had buckled in its flight and ended up covering him in a protective shield. He was completely uninjured. Fortunately, and even though the fires and explosions continued for seventy-four hours, only four people were killed in the blast.

Many important buildings in the city were struck by either incendiary or high-explosive bombs, including the Customs House, India Buildings, the Corn Exchange, the Central Library, Liverpool Cathedral, the Bluecoat Arts Centre, and the museum. However, the work of the port had to go on and people had to live their lives. They also managed to find ways to still get to work through destroyed and rubble-strewn streets. Morale in Liverpool remained very high and the people of the city were recorded as having the highest level of community spirit and positivity of any blitzed town or city in the country. Nevertheless, throughout Liverpool and its suburbs there were 15,000 bombed sites.

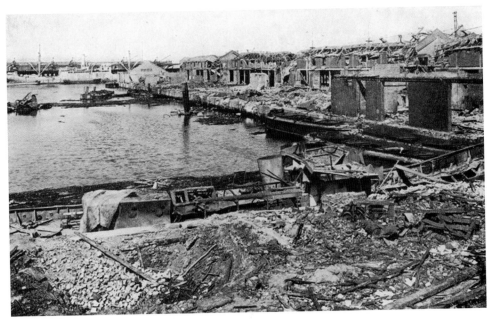

The destruction caused by the explosion of *Malakand*, which took a direct hit from a bomb. (Courtesy of Liverpool City Records Office)

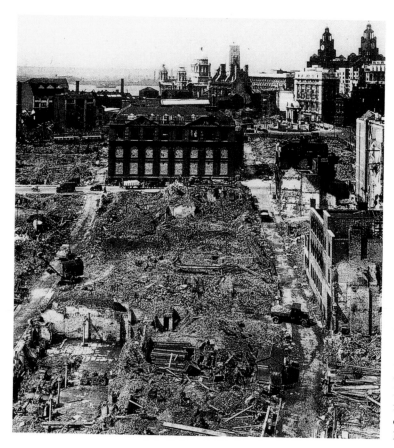

The city centre of Liverpool absolutely devastated by Nazi bombs in 1941. (Courtesy of Liverpool City Records Office)

Raids continued intermittently following the 1941 Blitz and, though still bad, these were not as terrifying as those that the people had already endured. Even so, there was still much damage to property and loss of life. Between August 1940 and January 1942, the Luftwaffe bombing raids over Liverpool killed over 4,000 people, and injured over 10,000 more. Indeed, in sheer tonnage of high-explosive and incendiary bombs, Liverpool was the most heavily bombed city outside London. On 14 May 1941, a mass funeral was held at Anfield Cemetery in the north of the city, at which 1,000 victims of the May air raids were buried in a common grave.

Considerably more than half the houses in the four principal boroughs of Merseyside were damaged and over 10,000 were destroyed. The people of Bootle, the small town on the immediate northern border of Liverpool, saw an overwhelming 80 percent of their homes damaged or destroyed. On just one night during the Blitz fifty bombs were dropped on Bootle. The overall housing loss in the Liverpool area was:

Liverpool: of 202,000 houses, 5,598 destroyed and 124,989 damaged.
Bootle: of 18,189 houses, 2,013 destroyed and over 14,000 damaged.
Birkenhead: of 35,727 houses, 2,079 destroyed and 26,000 damaged.
Wallasey: of 27,600 houses, 1,150 destroyed and 17,000 damaged.

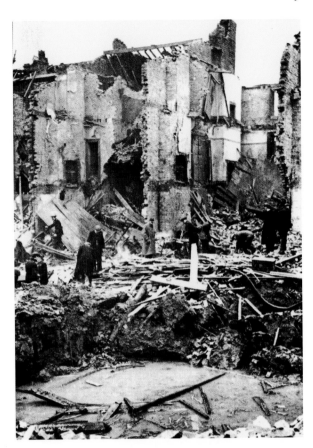

Searching for survivors after yet another Blitz air raid on Liverpool. (Courtesy of Liverpool City Records Office)

Throughout the entire May Blitz, 250,000 meals were served from mobile canteens. These included 25,000 gallons of tea, 2,000 gallons of Scouse, 21,000 dinners, and 360,000 sandwiches. At one time, 9,000 workers from outside the city, together with 2,680 troops, helped Liverpool's own workmen to clear away rubble and debris to get the streets open again. Firefighters from thirty-nine boroughs were brought in to supplement local fire brigades, and they brought with them and additional 550 fire engines. Sadly, eighteen firefighters were killed and 180 injured during the Blitz as they fought to control and extinguish hundreds of fires.

While the effects of the bombing of London were fully reported and broadcast, the government kept the full impact of the Blitz on Liverpool from the British people. Not only did they feel that this information would seriously undermine national morale, but it would show the Germans how effective their air raids were on the city. At that time, Liverpool was Britain's (and free Europe's) only fully functioning commercial port, and such secrecy was essential so that the enemy would not be encouraged to intensify their attacks. Indeed, information about the results of one particular bombing in Liverpool was kept a government secret until well after the war had ended.

In the early hours of 29 November 1940, during the heaviest air raid to date, a parachute mine fell on the three-storey-high Junior Instruction Centre in Durning Road in the

Liverpool district of Edge Hill. This caused the building to collapse into the air-raid shelter below, in which 300 people believed themselves to be safe from the bombing. The gas main and the central heating water pipes were fractured, and those victims who were not crushed under falling masonry were either burned alive in the resulting fireball, or boiled to death in the now super-heated water that flooded the basement.

Many others were buried alive, while fires burned uncontrollably above ground, making rescue work extremely dangerous. In all, 166 men, women, and children were killed and many more were severely injured. Winston Churchill described the disaster as 'the single worst civilian incident of the war', and the close-knit community of Edge Hill was devastated. This is said to be the only time during the war that the prime minister wept.

Following the end of the Second World War, in May 1945 servicemen returning to Liverpool came home to a ravaged city and an exhausted community. Food, fuel, and commodities were in short supply. Indeed, rationing continued until 4 July 1954, when restrictions on the sale of bacon and meat were finally lifted. Even so, there was a mood of great optimism, because the Germans under Hitler and the horrors of Nazism had been defeated and the world could begin to live again.

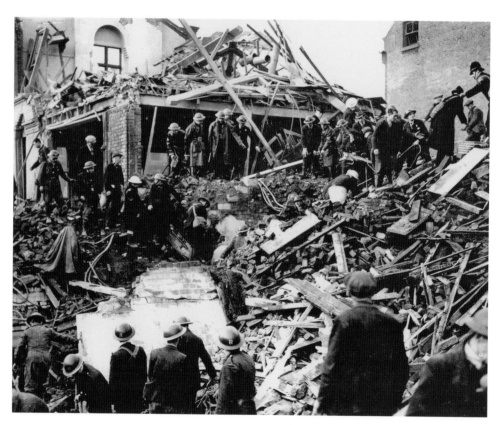

The aftermath of the Durning Road air-raid shelter disaster, in Liverpool's Edge Hill district. (Courtesy of Liverpool City Records Office)

Conclusion: Not Yet 'The End'

After the Second World War, to many people in Britain it seemed as if there really was a new dawn. Civilisation and progress could reassert themselves, and a fresh, decent society could be created. This was especially felt by the innately optimistic and dynamic people of Liverpool. As the late 1940s passed into the 1950s, the people of the city were discovering a new energy, a new determination to succeed, and a refocusing on family and community.

This revived sense of optimism was bolstered by the post-war boom in the global economy that was now taking place, and which was leading to a dramatic rise in the standard of living in Britain. There was also an increase in industrial and commercial production in the country, especially in the car, steel, and coal industries. Export earnings and investment were boosted too, and wages were beginning to rise as the trade unions gained confidence in their demands.

Nevertheless, since the war this optimism has been tempered by the harsh experience of a series of late twentieth-century economic failures. Also, the last seven decades have shown that, as yet, mankind still cannot live in harmony with itself or the world. We know to our cost that the curse of warfare continues across the globe.

The military heritage of Liverpool means that men and women of the city continue to serve their country in all the armed services. As in the past, they do so with dedication, courage, and honour; the people and city of Liverpool will always answer their country's call.

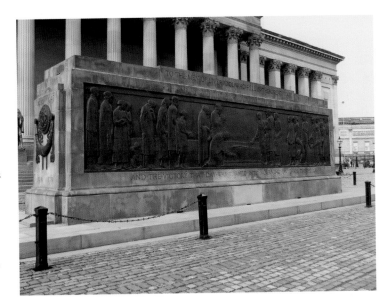

The cenotaph that stands on St George's Hall Plateau, in the heart of Liverpool, commemorates and pays tribute to all of the city's war dead – military and civilian. (Discover Liverpool Library)

Select Bibliography

Bailey, F. A., and Millington, R., *Story of Liverpool* (Liverpool: Corporation of Liverpool, 1957).

Brownbill, J. and Farrer, W., *A History of The County Of Lancashire* (eds) (Victoria County History, 1911).

Chandler, George, *Liverpool* (London: B. T. Batsford Ltd, 1957).

Charters, David, *Great Liverpudlians* (Lancaster: Palatine Books, 2010).

Chitty, Gill, *Changing Face of Liverpool: 1207–1727* (Liverpool: Merseyside Archaeological Society, 1981).

Colville, Quintin & Davey, James (eds), *Nelson: Navy and Nation* (Conway, 2014).

Crawford, Sally, *Anglo-Saxon England* (Shire, 2012).

Doyle, P., *Mitres and Missions in Lancashire* (Liverpool: the Bluecoat Press, 2005).

Griffiths, R., *Park of Toxteth* (R. Griffiths, 2007).

Hand, Charles, *Olde Liverpoole and Its Charter* (Liverpool: Hand & Co., 1907).

Heywood, T., *The Moore Rental* (ed.) (Manchester: the Chetham Society, 1847).

Hinchliffe, J., *Maritime Mercantile City* (Liverpool: Liverpool City Council, 2003).

Hird, Frank, *Old Lancashire Tales* (Liverpool: Frank Hird, 1911).

Hird, Frank, *Old Merseyside Tales* (Liverpool: Frank Hird, 1918).

Hollinghurst, H., *Classical Liverpool* (Liverpool: Liverpool History Society, 2009).

Hollinshead, J., *Liverpool in the Sixteenth Century* (Lancaster: Carnegie Publishing Ltd, 2007).

Howell, Williams, P., *Liverpolitania* (Liverpool: Merseyside Civic Society, 1971).

Jackson, J., *Herdman's Liverpool* (Parkgate: the Gallery Press, 1989).

Lane, T., *City Of The Sea* (Liverpool: Liverpool University Press, 1997).

Liverpool Heritage Bureau, *Buildings of Liverpool* (Liverpool: Liverpool City Planning Dept, 1978).

Maclean, Fitzroy, *Highlanders* (Adelphi, 2008).

Maddocks, Graham, *Liverpool Pals* (Pen & Sword, 2012).

McGreal, Stephen, *Liverpool in the Great War* (Pen & Sword, 2016).

McIntyre-Brown, Arabella, *Liverpool The First 1,000 Years* (Garlic Press, 2002).

McLeish, Harry, *Cammell Laird: The Inside Story* (Trinity Mirror, 2012).

Moore, J., *Underground Liverpool* (Liverpool: the Bluecoat Press, 1998).

Muir, R., *A History of Liverpool* (London: Williams & Norgate, 1907).

Noel-Stevens, J., and Stevens, M., *Hidden Places of Lancashire and Cheshire* (Guernsey: M & M Publishing, 1991).

Pearce, J., *Romance of Ancient Liverpool* (Liverpool: Philip, Son & Nephew, 1933).

Picton, Sir J., *Memorials of Liverpool* (London: Longman, Green & Co., 1873).

Power, M., (ed.), *Liverpool Town Books 1649–1671* (Stroud: Sutton Publishing Ltd, 1999).

Rowley, Trevor, *Norman England* (Shire, 2012).

Stonehouse, J., *The Streets of Liverpool* (Liverpool: Hime & Son, 1907).

Thomas, H., *The Slave Trade: History Of The Atlantic Slave Trade, 1440–1870* (New York: Simon and Schuster, 1997).

Various contributors, *A Guide to Liverpool 1902* (London: Ward, Lock & Co., 1902).

Whale, Derek, *Lost Villages of Liverpool: Part One* (Prescot: T. Stephenson & Sons, 1985).

Whitworth, Rodney, *Merseyside at War* (Liverpool: Scouse Press, 2016).

Acknowledgements

I certainly hope that you have enjoyed this concise exploration and celebration of the military history and heritage of the remarkable city of Liverpool, and of its equally remarkable people.

It was a real pleasure to research and write this book, the latest in my series describing so many aspects of the lives and histories of the large and diverse community of Liverpool city region. To be a native Liverpudlian is a continuing source of personal pride and joy. Investigating the more significant elements of our military heritage has only reinforced this.

It was not a complex job to research this book, but it was demanding. I thank my many friends for helping me with this, but especially my children, Ben, Sammy and Danny, and my wife Jackie.

For the sources for my stories I would also like to acknowledge, as always, the professionalism and support of my fellow members of the Liverpool, Wavertree, Woolton, Garston, and Gateacre Historical Societies; the librarians of the Athenaeum (in particular Vincent Roper); and the staff of the Liverpool City Records Office.

About the Author

Born and bred in Liverpool, Ken Pye FRSA recently retired as the managing director of the Knowledge Group. In a varied career spanning over forty-five years, Ken has experience in all professional sectors. This includes working as a residential child care officer for children with profound special needs, as a youth and community leader, as the community development officer for Toxteth, the North West regional officer for Barnardos, the national partnership director for the Business Environment Association, and senior programme director with Common Purpose.

However, he continues as managing director of Discover Liverpool. As such, Ken is a recognised expert on the past, present, and future potential of his home city and is a frequent contributor to journals, magazines, and newspapers. He is also a popular after-dinner speaker and a guest lecturer to a wide range of groups and organisations. He is also a regular broadcaster for both radio and television. Ken is a fellow at Liverpool Hope University, a fellow of the Royal Society of Arts, and a proprietor of the Liverpool Athenaeum.

Well known across Merseyside and the North West, Ken is the author of over twelve books on the history of his home city and its city region, and is a widely recognised expert in his field. Ken's books include *Discover Liverpool* and *The Bloody History of Liverpool* (both of which are now in their third editions); *A Brighter Hope* (about the founding and history of Liverpool Hope University); two volumes of his anthology of *Merseyside Tales*; his complete history of the city, *Liverpool: The Rise, Fall and Renaissance of a World Class City*; *Liverpool Pubs*; *Liverpool at Work*; and *The A to Z of Little-Known Liverpool*.

Having also completed two private writing commissions for the Earl of Derby, Ken has just issued his set of four audio CDs on which he tells his stories of the *Curious Characters and Tales of Merseyside*. Also available is Ken's brand-new, fully revised third edition of his eight-volume DVD documentary series *Discover Liverpool*.

On a personal basis, and if pressed (better still, if taken out to dinner), Ken will regale you with tales about his experiences during the Toxteth riots, as a child entrepreneur, as a bingo caller, as a puppeteer, as the lead singer of a 1960s pop group, as an artists' model, and as a mortuary attendant.

Ken is married to Jackie, and they have three grown-up children: Ben, Samantha and Danny.

Visit Ken's website at www.discover-liverpool.com.

Ken Pye FRSA with his family. (Courtesy of Discover Liverpool Library)